Beautiful Stuff from Nature

More Learning with Found Materials

EDITED BY CATHY WEISMAN TOPAL AND LELLA GANDINI

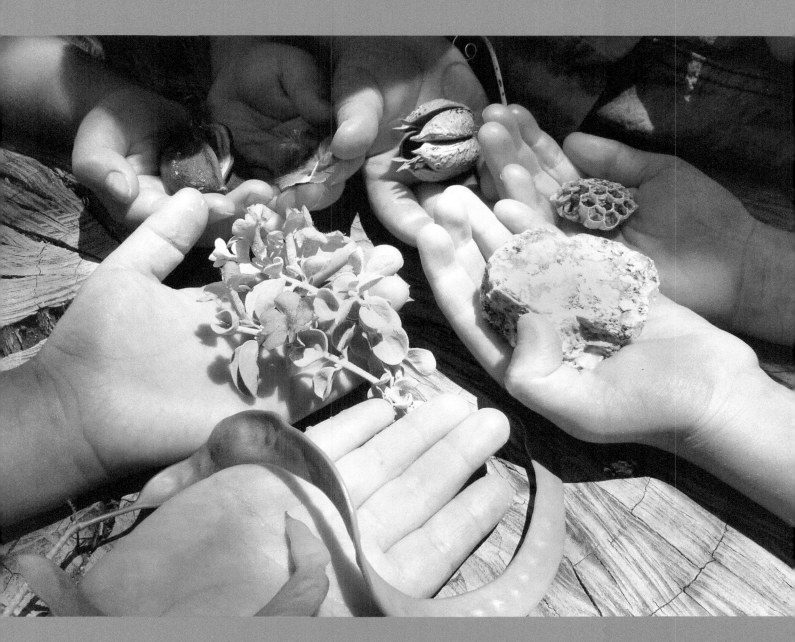

Davis Publications, Inc.
Worcester, Massachusetts

Publisher Julian Wade
Senior Editor Missy Nicholson
Editor Emily Henderson-Sperber
Art Director Julia Wade
Designers Tyler Kemp-Benedict,
Tina Henderson, Douglass Scott
Production Assistance Tom Fiorelli, Amanda Hebson,
Bret Laurie, Victoria Hughes Waters

Contributing Schools

Acorn School, Toronto, Ontario, Canada

Albuquerque Public Schools, Albuquerque, New Mexico

Beginnings Nursery School, New York, New York

The Bishop Strachan School, Toronto, Ontario, Canada

Campus School of Smith College, Northampton, Mass.

Center for Early Childhood Education, Smith College,
Northampton, Massachusetts

Cyert Center for Early Education, Pittsburgh, Pennsylvania

Giles Early Education Project, Giles County, Virginia

Lander~Grinspoon Academy, Northampton, Massachusetts

L'Atelier School, South Miami, Florida

Lincoln School, Providence, Rhode Island

McGehee's Little Gate, New Orleans, Louisiana

mem7iman Child Development Centre, shíshálh Nation,
Sechelt, British Columbia, Canada

Myrtilla Miner Elementary School, NE Washington, DC

Pinnacle Presbyterian Preschool, Scottsdale, Arizona

Riverfield Country Day School, Tulsa, Oklahoma

Sabot at Stony Point, Richmond, Virginia

Touchstone Community School, Grafton, Massachusetts

*The images in this book were taken by the teachers in each story.
Cover photo provided by The Bishop Strachan School.*

About the Editors

Cathy and Lella met many years ago at the Center for
Early Childhood Education at Smith College and have
collaborated ever since. Working together on research,
workshops, professional development, conferences, books,
documentation panels, and exhibitions has deepened their
knowledge and friendship.

Cathy Weisman Topal is a research associate at Smith
College, and a longtime studio art educator at the
preschool, elementary, middle school, and college levels.
For over thirty years, she taught visual arts education in
the Department of Education and Child Studies at Smith
College in Northampton, Massachusetts, and was the studio
art teacher at the Center for Early Childhood Education
and the Campus School of Smith College. Cathy is the
author of several books and visual arts curricula, including
Children, Clay, and Sculpture; *Children and Painting*; *Beautiful
Stuff: Learning with Found Materials*; *Thinking with a Line*;
Explorations in Art: Kindergarten; and *Creative Minds Out
of School*. Cathy recently created an interactive website:
www.thinkingwithaline.com. She is a frequent speaker and
workshop facilitator in the U.S. and abroad.

Lella Gandini is the associate editor of the journal
Innovations in Education: The International Reggio Exchange.
She has conducted research and held faculty positions at
the University of Massachusetts, Smith College, and is a
visiting scholar at Lesley University. She has led professional
development sessions, lectures, and workshops and has
coproduced videos, articles, and interviews on the Reggio
Emilia approach for educators in the U.S., Canada, Mexico,
Italy, and Japan. She has published or coedited several books
in Italy and in the U.S., including *The Hundred Languages
of Children: The Reggio Emilia Approach to Early Childhood
Education, Beautiful Stuff, In the Spirit of the Studio: Learning
from the Atelier of Reggio Emilia, Bambini: The Italian
Approach to Infant/Toddler Care, Insights and Inspirations from
Reggio Emilia*, and *The Hundred Languages in Ministories*. Her
curatorial and editorial work has been widely published.

ISBN 978-1-61528-678-2

LOC 2018948889

10 9 8 7 6 5 4 3 2 1

Acknowledgments

It is with pleasure and gratitude that we acknowledge the many teachers of young children from all over North America who have been exploring materials from nature with their students and who have contributed the stories in this book. Many years of visiting the schools and working back and forth with the authors of each story has brought explorations to deeper levels at the same time that it has clarified our vision for this book.

Our first book together, *Beautiful Stuff: Learning with Found Materials,* is the story of a classroom of four- and five-year-olds. It follows the evolution of a way of working inspired by principles of the Reggio Emilia approach. As children and teachers explored their collections of found materials, we all began to pay close attention to the children's comments, relationships, and investigations that began to emerge. Our process became supporting and documenting what we observed. Lella Gandini was our fellow researcher and guide, posing questions that challenged our beliefs and assumptions when we hit a roadblock.

Seeing *Beautiful Stuff* in so many schools and early childhood centers in strikingly different regions and environments has been a great pleasure. It validated our belief that teachers throughout North America had been looking for guidance and ways to get started working with this new approach from Italy. In a sense, *Beautiful Stuff* became a catalyst for change. It gave us the desire to offer a new line of research.

There is a tendency today to have a crowded landscape of materials that children, parents, and teachers have to navigate. There is a danger of losing contact with nature. To get close to nature we must clear visual and mental space and let in the many subtle aspects of the natural world. There is a world of learning right outside the door, if only we can access the possibility to see, smell, touch, and listen with all the senses as demonstrated in these stories.

Lynn Hill, with her deep experience and sensitivity to nature and her close reading of the stories, helped us to see themes and how they could be organized and offered. She also researched poetic statements about children and nature. It has also been essential to have Emily Henderson-Sperber following and supporting us throughout every step of this process. She has been a friend for us and a critical expert in her field of editing.

We were not able to publish every experience, but many friends and colleagues responded to our request, showing their support and interest. We would like to acknowledge and thank Julie Bernson, Val Driscoll, Laura Fynes, Patti Pappas-Green, Diane Kashin, and Martha Lees.

In effect, we intend for the stories in this book to open even more ways to look closely, observe, and reflect with all of one's potential on the wonder of learning from nature.

Contents

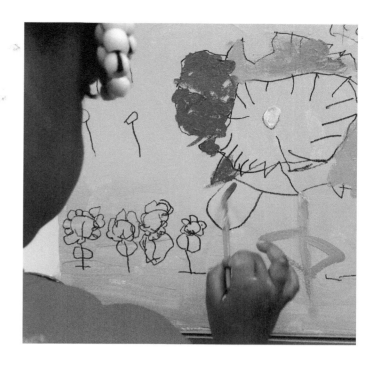

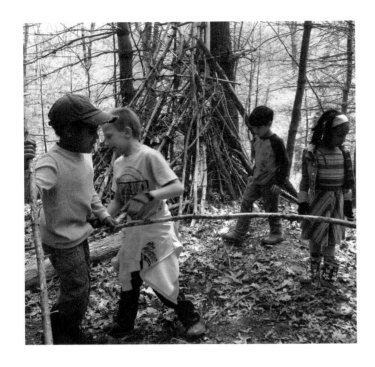

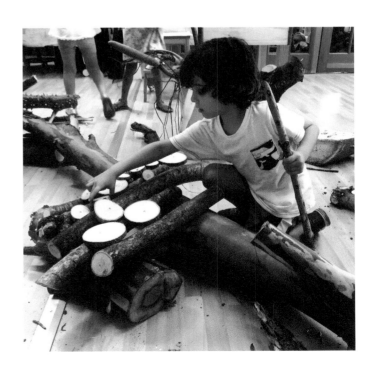

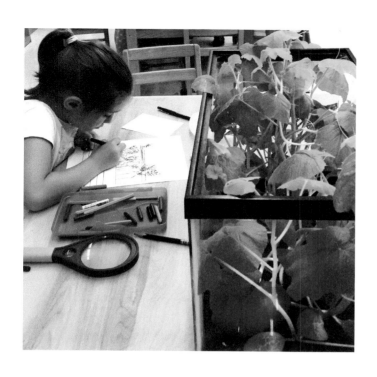

SECTION 5

Bringing Nature Inside

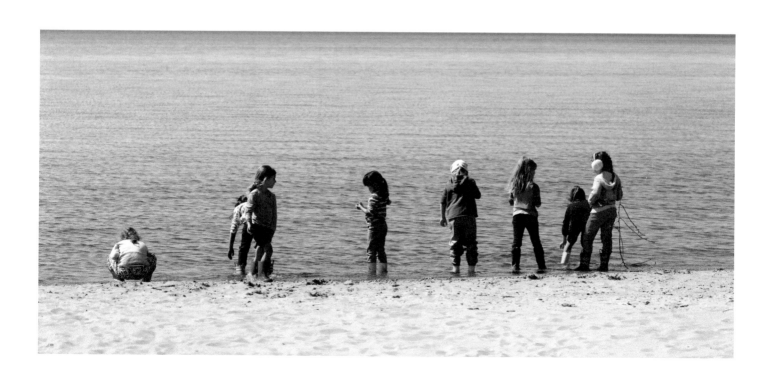

Introduction

Nature does not hurry, yet everything is accomplished. —Lao Tzu

Children are natural explorers, open to the surprise that nature brings. The first book in this series, *Beautiful Stuff*, is about using found objects to inspire child-centered early learning. This book is a natural companion to that philosophy. Natural materials give us a window into growth and change. Working with organic objects involves a different aesthetic than interacting with human-made forms. It's a more subtle aesthetic that can lead to deeper, more mindful creative work in all disciplines. However, it is the teacher's attention to children's discoveries, questions, and theories about natural materials and phenomenon that is the key to enhanced learning.

Today's parents and educators are conscious of children's need to spend more time outdoors. There is beauty in nature in every place, and the children deserve to find it! By exploring nature with children—looking through their eyes and listening to their questions and theories—teachers and parents can find new approaches to learning. Exploring, experimenting, researching, designing, and creating with natural materials can act as an awakening for children—but perhaps even more so for teachers! To notice and pick up a seedpod, twig, stone, blade of grass, or piece of bark draws us in and invites us to linger and to wonder. We start to see—with refined vision—what has been around us all along. Holding a natural form is to look at functional design, transformation, time, weather, and the forces of nature.

We are well aware of the expectations and demands on teachers to meet standards in the STEM subjects—science, technology, engineering, math (art educators prefer the acronym STEAM, which includes the arts)—as well as in the language arts and social-emotional growth and development. We offer the explorations in this book as ways of meeting learning standards in all of these areas. Standards, expectations, 21st century skills are often viewed as being imposed from the outside, but in fact, we view them as opening and expanding windows of possibility. The natural world offers an infinite variety of open-ended materials that teachers and children can use to explore the intention of a standard in a freer way.

The experiences documented in this book are foundational. They show that when we pay attention to children's discoveries and persist in following them to deeper levels, the results can be quite extraordinary. We chose each story to highlight a different aspect of teaching and learning. Each exploration represents a fraction of the experiences documented by the teachers. Each school has a website with more information about its specific programs. These stories come from all over North America. They come from teachers seeking ways to use the outdoors more effectively, from teachers who want to enrich their science curriculum, and from teachers looking to incorporate mindfulness into their classrooms. These stories come from urban schools and rural schools, public schools and private schools, early childhood centers, preschools, kindergarten through fourth-grade teachers, studio art teachers, and after-school teachers. The explorations are relevant for children of all ages, and the approaches encourage active engagement in learning.

The preschools of Reggio Emilia, following the inspiration of Loris Malaguzzi, have chosen to have an atelier (art studio) and at least one teacher—an atelierista, or studio art teacher—who works and supports the children and the other teachers in their explorations and creations with materials. The teachers in the United States have embraced this initiative. Principles of the Reggio Emilia approach inspired us in our careers and have influenced many of the teachers in this book.

Principles of the Reggio Emilia approach include:

- A deep respect for the ideas of children and teachers that go beyond the standard expectations.
- A belief that knowledge is constructed through social exchange.
- A belief that materials and media are powerful tools for constructing and communicating ideas, theories, and understandings.
- Documenting children's and teachers' processes so that we can:
 - preserve moments of discovery and connection,
 - see how projects emerge,
 - understand the evolution of in-depth work and how it is sustained,
 - give visual recognition to children's and teachers' work, and
 - make learning visible to parents and the community.
- A belief that collaborating with other teachers and children in the search for knowledge and understanding is satisfying, critical, and beneficial.

Witnessing moments of discovery with materials from the environment and seeing where they lead is what has inspired the authors of the stories in this collection. Being outside in nature with children brings us together in communal learning. We hope the explorations in this book will inspire and encourage you to look closer—through the eyes of children—at your own little piece of the planet.

Cathy Weisman Topal and Lella Gandini

Getting Started

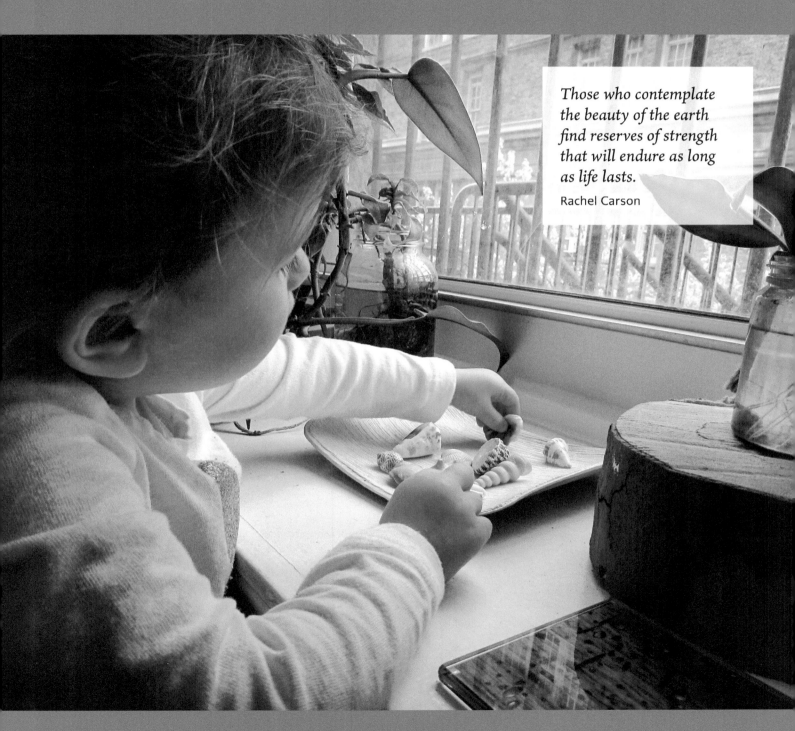

Those who contemplate the beauty of the earth find reserves of strength that will endure as long as life lasts.
Rachel Carson

Introducing Children to the Materials

Two Ways That I Begin

BEGINNINGS NURSERY SCHOOL
NEW YORK CITY

Amy Miller, Studio Teacher

Beginnings Nursery School, a progressive preschool inspired by the Reggio Emilia approach, is located just east of Union Square in New York City. The school day is separated into two programs, morning and afternoon, for children age eighteen months to five years. We follow an emergent curriculum based on the interests of the children.

The natural and found materials available for the children to use in the studio are supplied by our materials center. This storeroom is maintained by teachers with the help of parent volunteers, who also donate materials from their workplaces and communities.

Shelves in the studio display bins of materials from each category in the materials center—natural materials, wood, wire and metal, ceramics, plastic, leather, and castoffs from architectural models. Other shelves offer drawing and painting materials, as well as a variety of paper for the children to select from.

The natural materials include river rocks, marble cubes, sticks, shells, acorns, and twine. This area also offers corks and blocks of wood shaped like houses. These might technically be considered found objects, but we prefer to sort the objects by material rather than by how it was processed before coming to us.

Many of our natural materials are gathered locally, as one would expect: acorns and their tops are collected from parks and yards; shells return with the children from vacations on Long Island; sticks are picked up as the children go for walks in the parks.

The more unusual items come from our teaching staff. I carve marble and travertine. One day while carving, I looked down at my feet and noticed a pile of beautiful stone cubes. I displayed these in bamboo boxes, arranged by type of stone and color. The cubes are part of nearly every arrangement the children do. They are drawn to them, possibly because of their rarity.

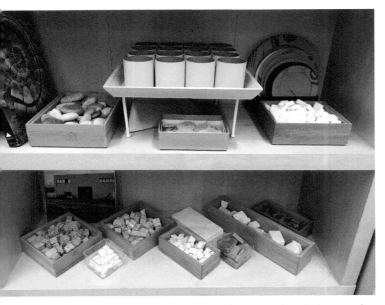

Neatly arranged materials in containers on the shelves entice the children and inspire design-work.

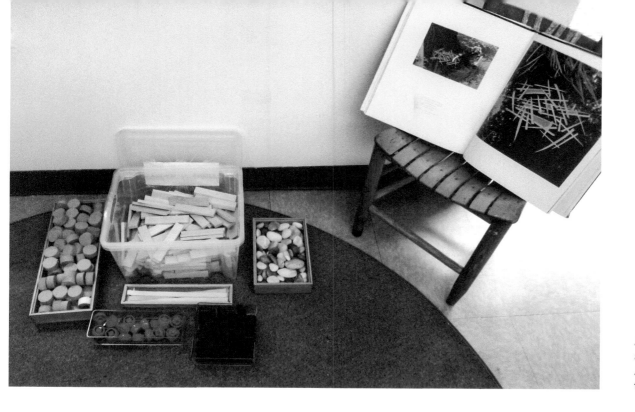

A setup of materials and a photograph by Andy Goldsworthy for inspiration.

Setting Out Materials and Inspiration

When introducing children to the materials, there are two ways I begin. The first is to create a setup on the studio's large round rug or on a table. When choosing what to offer, I consider shape, color, texture, and material. I often mix natural and found objects to achieve a variety of qualities for the children to explore. Sometimes I display an image by artist and photographer Andy Goldsworthy with the materials.

Sometimes the children come into the studio and are presented with a small arrangement I have created. For example, I may set river rocks in a line with another material, reflecting an accompanying photo. I encourage the children to observe similarities and differences between the photo and the arrangement, and then to slowly make changes. I create simplistic designs like this to help the children see how to start making their own creations.

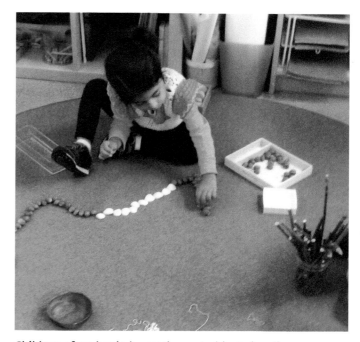

Children often begin by setting out objects in a line. As they become familiar with the studio space and the materials, their designs become more elaborate.

3

Choosing a Material to Explore

The second way I introduce children to the materials in the studio is more fluid and organic. This method is useful when the children are new to the school and the studio. The classroom teachers and I have noticed that the young three-year-olds are the most interested in working with materials this way.

I welcome the children into the studio and ask them to sit with me on the rug. We talk about what we can do together in the studio. Then I ask them to go look at the materials on the shelves. I have each child choose one container to bring back to the rug. Some are drawn to the bright colors of the plastics, some to the cold, shiny metals, and others to the soothing browns and tans of the natural materials.

As the children bring their containers to the rug, I provide the name of each material. Depending on the children's reactions and interest level, I may suggest they return a container to the shelf and select another. Then I say, "What can we do with this material?" or "How can we use it to make a design?" or "I noticed that you all chose materials that are round [or long or shiny...]." Often the children ask to dump the containers out on the rug—there is a certain joy in dumping. Then they make designs—roads or train tracks or cities or simply shapes.

When all the materials from a container have been used, I suggest they go find another to add to their design. The children often consider the options for a

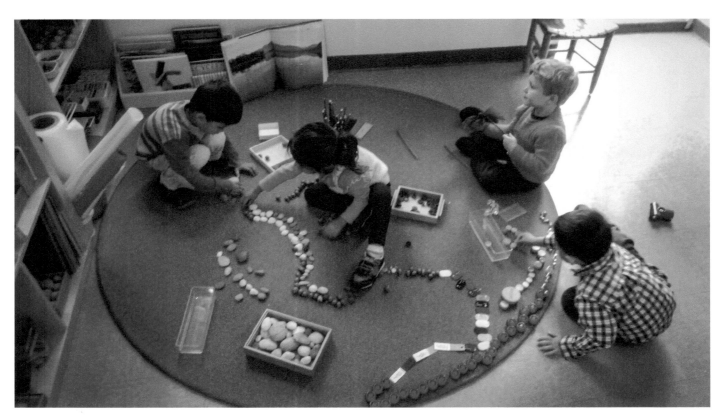

Each child brings a container to the rug. There they explore the materials and set them out with care.

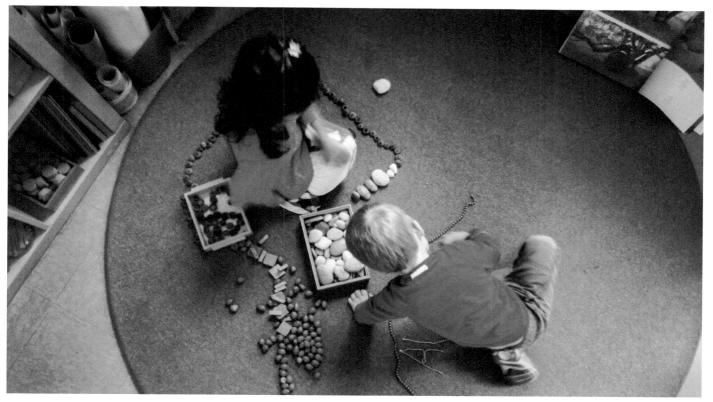

Lyla carefully arranged materials in a circle around herself each time she came to the studio. It seemed to calm her.

long time before selecting. Then they will bring the new container to me and ask "What is this?" I provide a name for it, as descriptive as possible, and ask how they are going to add it to their work. Sometimes the names are simple, like river rocks; sometimes they are complex, like yellow plastic grids.

This process goes on and on, around and around. Through these methods, the children get to know the materials in the studio, their names and qualities, and how they can use them to convey their ideas. ❧

After exploring an arrangement of shells, Lila holds one to her ear to hear the ocean.

Making Learning Visible through Documentation

RIVERFIELD COUNTRY DAY SCHOOL
TULSA, OKLAHOMA

Kacey Davenport and Jennifer Kesselring,
 Preschool Co-Division Heads
Jennifer Norviel, Toddler Teacher

Riverfield Country Day School is an independent school for children eight weeks old through twelfth grade. The school is located on a 120-acre campus with open fields, a barnyard with animals, walking trails, and vast wooded areas for hiking. Riverfield has been deeply inspired and motivated by the educational movement in Reggio Emilia, Italy.

Our school was built with attention to reciprocity between indoors and outdoors. Our classrooms have floor-to-ceiling windows that further this exchange. Both inside and outside, spaces are constantly being transformed as seasons change.

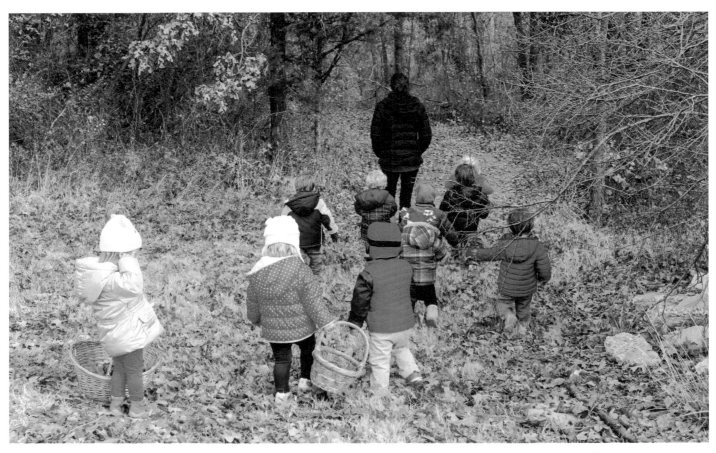

Toddlers take walks through the wooded trails on our campus to gather natural materials for the indoor atelier.

Experimentation in the Mini-Atelier

In the toddler classroom, designed for children ages twelve months to two years, we have set up a mini-atelier, or studio. We brainstormed and provided materials to encourage smelling, touching, stirring, squishing, blending, and symbolic representation. The children collected natural materials on walks, and teachers and parents contributed herbs, spices, tea leaves, pine cones, and dried flowers, as well as bowls, spoons, measuring cups, funnels, strainers, and a pestle and mortar—materials that stimulate the senses and spur action.

Teachers accompany the children's initial investigations for support, then the children explore by themselves as we keep a watchful eye. We set ourselves the goal of closely observing and documenting their encounters.

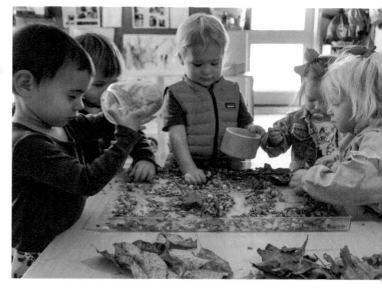

As children explore, they question why some leaves, twigs, and acorns crumble.

The natural atelier is a space to get a little messy and further the exchange between inside and outside.

Saving Traces of the Children's Explorations

The teachers stand back and observe as the children explore. It is hard to watch and not interfere, but we want to understand how the toddlers will spontaneously interact with the materials.

Saving a trace or a memory of an experience is so important to the art of learning and teaching. We record and document the children's explorations in a variety of ways. In order to understand what we are witnessing, we photograph their subtle expressions and actions in sequences. We record their words and our thoughts as we observe them.

This process of documenting leads us to see so much more. It helps us appreciate the intelligence of toddlers. We learn so much about how young children interact with materials and with each other. Documenting also deepens our work. By sharing our findings with parents, we help them understand the valuable educational experiences their children are having.

Aubrey Invents a New Technique

Throughout the classroom, we notice the children are grappling with the concept of transformation. *How does light change when our body moves in front of it? What happens when I mix colors of paint? How does a piece of clay change as I pull it apart and put it back together in a new way?*

A few of the toddlers create a pallet from a large rock slab collected on one of our walks in the woods. They choose leaves, acorns, and flower petals and discover they can transform materials by using stones like a pestle and mortar. These activities catch our attention and move our work forward.

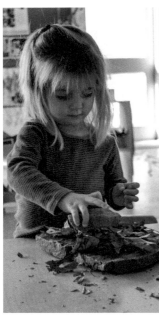

Aubrey, 26 months, creates a transformation technique by rubbing a rock over leaves on a stone pallet.

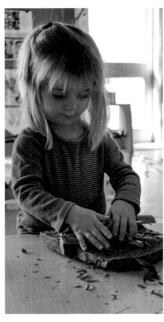

Using both hands to apply more pressure, she watches closely as the leaves begin to change.

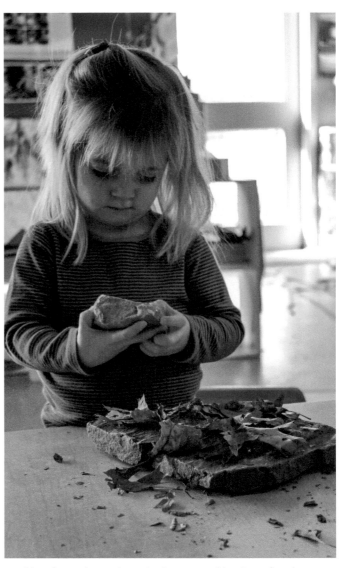

Looking from the rock to the leaves and back again, she appears to be investigating what happened, what changed.

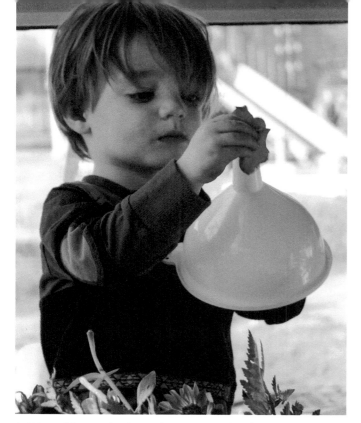

1. Wryn, 22 months, investigates materials in the natural atelier. He tries to put a large flower petal through the narrow end of the funnel.

Observing Collaboration between Two Children

Often children's exchanges are so subtle we miss them. By paying close attention and documenting, we can notice and reflect on these fleeting moments. After the children leave for the day, the teachers discuss the notes, observations, and photos we have collected. For each sequence we generate a list of terms to describe the actions. In order to notice the subtle interactions, we look closely at the photos and ask, *What is happening in this sequence?*

- Experimentation
- Cooperation
- Collaboration
- Systematic research
- Communication

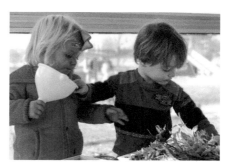

3. The pair work together, changing the position of the funnel for better results.

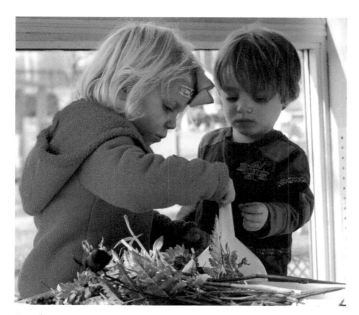

2. Paige, 24 months, notices Wryn's efforts and offers her help.

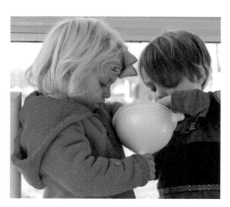

4. Using their new technique, Wryn and Paige test materials of different shapes and sizes.

A Story of Growing Relationships

Documentation has shown us that even young toddlers can navigate social interactions and create peer relationships—without a teacher directly introducing a problem or encouraging collaboration. Notice the gestures, focus, and body positions—the contagious ways children use to communicate.

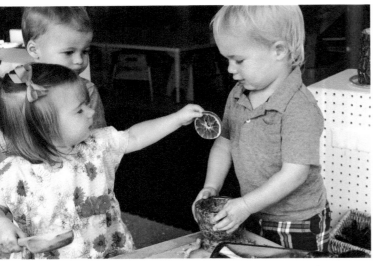

1. Ainsley, 16 months, offers a dried orange to Brooks, 23 months.

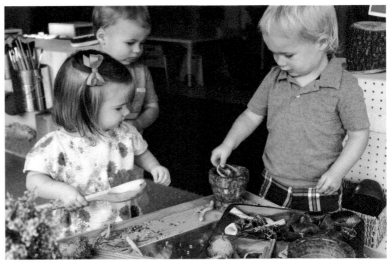

2. He accepts and places it in the mortar bowl. Lincoln, also 23 months, observes.

What is happening in this sequence?

- Care
- Friendship
- Exchange
- Dialogue
- Social learning
- Collaboration
- Reciprocity

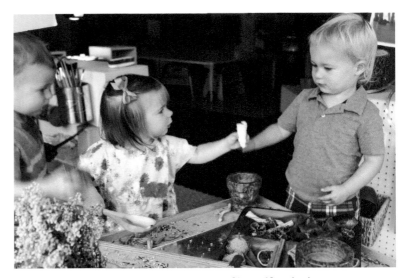

3. Encouraged by Brooks's acceptance of her gift, Ainsley offers another object.

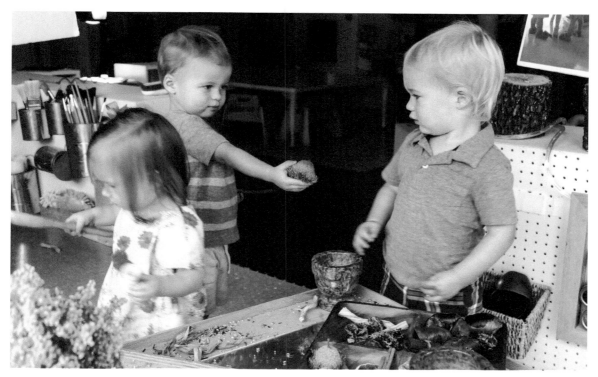

4. As Ainsley and Brooks continue their game, Lincoln enters into the dialogue.

Teaching Parents Too

We wanted the parents to better understand what their children were learning at school. After sharing the idea of documentation and several examples on parents' night, we invited parents to explore, create, and build in some of the centers in our classroom. We also invited them to observe, document, and reflect on their discoveries with one another. This process helped them understand our new teaching approach and really brought our parent community together. We were, in essence, following the examples demonstrated by the children!

Saving traces of the children's explorations and creating documentation has become a tool for daily analyzing, teaching, and learning. Documentation has given us a window into what is really happening,

why it is important, and what it means for our next steps in the classroom.

Riverfield Country Day School has a great respect for the possibilities that nature holds for children. The natural world offers unique experiences with light, color, smell, space, size, texture, sound, and so much more. These qualities are dramatically different from those offered by commercially made materials. In nature, children are invited to move big, breathe deeply, take risks, share their discoveries, and research both alone and with others. As the children immerse themselves in nature, we will continue to notice and document the development of relationships, recognize life patterns and changes, and observe them connecting to the world around them. ∾

Creating a Culture of Engagement

SABOT AT STONY POINT
RICHMOND, VIRGINIA

Marty Gravett, Director of the Sabot Institute
 for Teaching and Learning
Sara Ferguson, Preschool Teacher-Researcher

At Sabot at Stony Point in Richmond, Virginia, the preschoolers love exploring the playground and historic walled garden. The three-year-olds have a natural inclination to pick up sticks, leaves, and pebbles and stuff them in their pockets or carry them into the classroom. For some, these serve as transition objects, helping them bridge the shift from outdoors to indoors. The sheer prevalence of this act impelled us to find ways to include these materials in the classroom. We, the teachers, realized that we needed to catch up

We display the natural materials in transparent containers so children and teachers can easily see and access them.

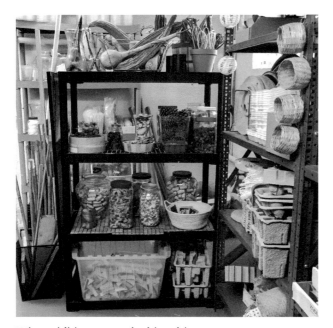

When children come inside with treasures, we are ready with baskets and space on the shelves.

to the children! We needed to find ways to show that we valued their interests and efforts.

We decided to create a space in our classroom for the natural materials. Our shelves now display a rich collection of objects found around the school and playground: acorns of various colors and sizes, cones—including the sought-after rose cone—which issue from a variety of conifers, gum balls from the sweet gum tree, and gourds from the community garden. Oak leaves, wisteria pods, nuts, and seeds are also found.

An Invitation to Provoke Engagement

After all our efforts, we were disappointed to find that once these natural materials were inside, the children showed little interest in them. We decided to try inviting the preschoolers to share their discoveries on a circle of black felt, to encourage them to look again at the objects they had collected. This exercise made all the difference, renewing their interest in the natural objects they brought to the circle and in those brought by other children.

A Conundrum for the Teachers

The children had a great time creating displays from loose natural materials and sharing them. Naturally, they wanted to keep what they had constructed. This created a conundrum for the teachers: *Are the materials a collective classroom cache, to be used by all again and again? Or should they become part of permanent creations and sent home?* Such artworks would be difficult to transport and would likely fall apart, as natural materials tend to become dry and brittle.

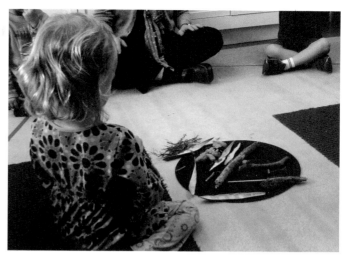

A felt circle provides a display space for the children's collections and shows off the unique properties of the natural objects.

Children love learning to use a camera.

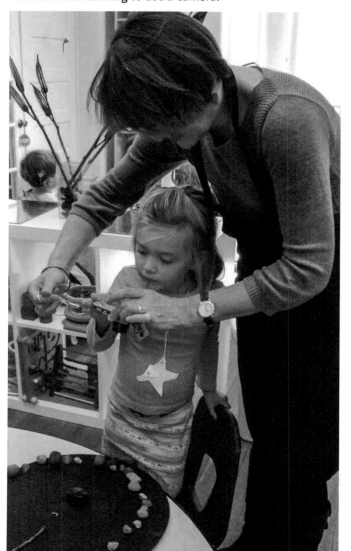

Photography—Another Way to Save a Memory

The teachers decided that the natural materials in our collection were meant to be used again and again. We told the children and introduced the idea that they could save a memory of their creation by taking a photograph or by drawing their work.

The children learned photography skills. By using a camera, they could step into the role of documenter. The photos they took helped them revisit the experience and reengage with the materials, leading to more complex creations. When children see a photograph of a child creating, or of a child's design, it often ignites their interest and engagement. In subsequent days, we created provocative setups of materials along with the photographs, to invite them to continue touching, exploring, and designing.

13

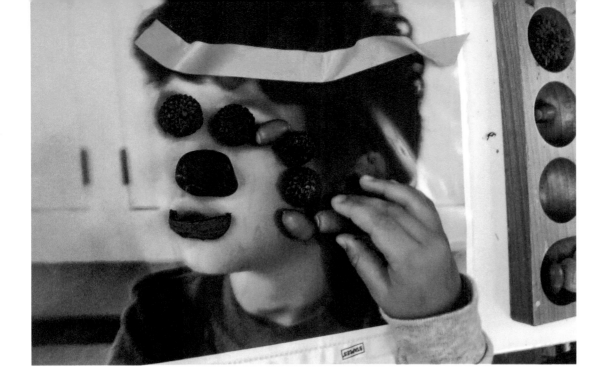

Photos set out near a variety of materials engage children in looking closely at their facial features and finding ways to symbolically represent them.

Portrait Play

We printed photos of each child and made them available for exploration. We did not know how they would use them. One day, the children used their images as maps for making faces with the natural materials.

Storytelling with Materials

While sharing their materials during circle time, the children began to spontaneously create people. The materials took on a new life in individual and collaborative constructions.

Displaying photos taken by the children and images of classmates at work with materials furthers their natural inclination to touch and arrange.

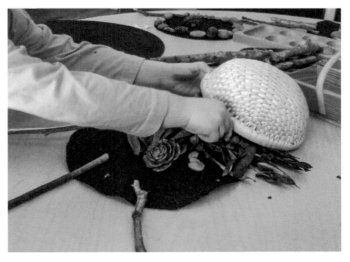

The children retrieve familiar objects from other areas of the classroom to represent features and body parts.

As the children worked representationally with the materials, we began to overhear dramatic dialogue and stories. We kept clipboards nearby to record the children's words. They loved to hear their stories read aloud, answer questions from their classmates, and share them with parents.

A Permanent Change in Culture

We were slow to realize how important natural materials had become in our school. Then we began to notice that educators visiting our campus frequently commented on the use of these materials in the classrooms. Now we embrace that aspect of our work and value the attention we place on natural materials.

The natural world provides us with a wide and clarifying lens for observation and documentation. Once we found ways to highlight the value of the materials, the explorations became contagious, moving from classroom to classroom, year to year. At the beginning of each year, students find natural materials left behind by the class that preceded them. When children see the work of other children, it sparks their interest and captures their imagination. The shelves of natural objects show them that we welcome the treasures that enter the classroom in little hands and pockets. This process has become a rich part of the Sabot culture—a part of how we define ourselves. ❧

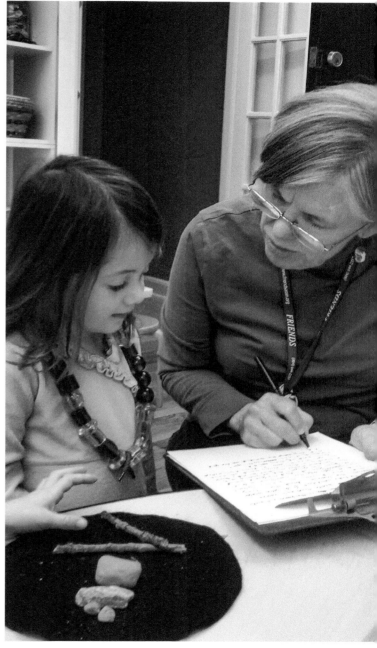

A teacher listens closely and writes down Julia's story about her creation.

Windy, a Presence in Our School

MCGEHEE'S LITTLE GATE
NEW ORLEANS, LOUISIANA

Mimi Odem, Curriculum Coordinator
Meredith Duke, Teacher of Two-Year-Olds
Renee Hemel, Assistant Director

Louise S. McGehee School is a private, all-girls school for preschool through grade 12, located in New Orleans. Little Gate preschool is inspired by the Reggio Emilia approach. Windy, a very special bald cypress tree, is an integral part of Little Gate. Windy was planted in our schoolyard 23 years ago as a 3-foot sapling. We chose a Louisiana bald cypress—our state

A mirror placed at the base of Windy's trunk opens up a magical new perspective.

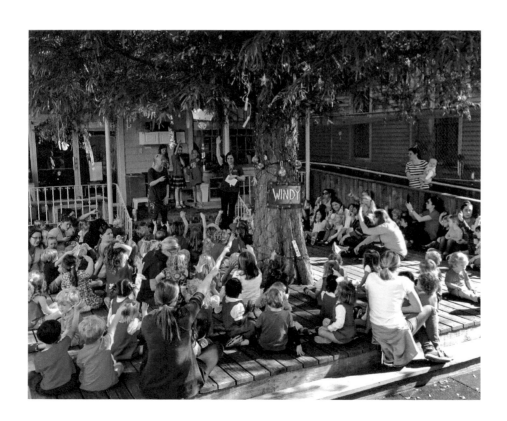

Windy has been the setting, the stage curtain, and a character in hundreds of dramatic plays and celebrations.

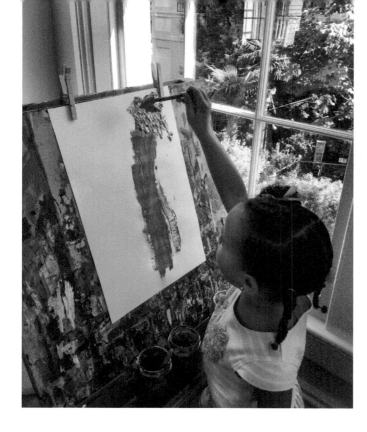

Harper's painting reflects Windy's massive height.

tree—for its ability to grow quickly in the wet, swampy soil. She gives us much-needed shade in the hot Louisiana climate. She helps us understand seasons, since she is one of the few deciduous trees in our area. She sheds her leaves in the fall, is bare in the winter, and grows green again in the spring. She is home to many animals, mostly squirrels, who love her cypress balls (seeds). She greets us, strong and full of life, in our playground at the start of every school year. She watches over us as the months pass. Then she waves goodbye at the start of summer. We have designed curricula, playgrounds, and school buildings around Windy's roots, trunk, and branches.

Windy offers the children a place to play, to stop, quiet themselves, and breathe deeply, and to dream. She is a strong, wise presence, reminding us daily of the importance and influence of nature in our lives.

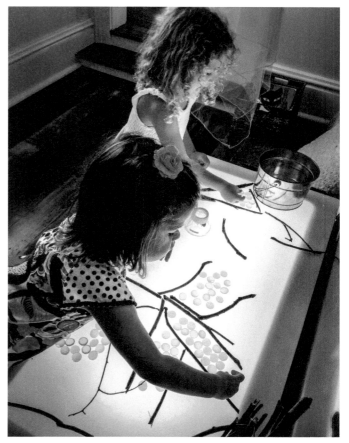

Sticks and loose parts on the light table reference the light that filters through Windy's branches.

Madeline draws Windy's thick, round trunk and radial branches.

Adelaide draws Windy's many branches and leaves.

An Annual Celebration of Life

Each November, we gather as a community to celebrate another year of life for Windy. We chart her growth—both width and height. We invite parents to the celebration, and we make decorations for her branches in preparation for the barren winter. We reflect, as a group, on why she is so important to us. We sing songs to Windy and dance under her protective embrace.

We invite the children to sketch, paint, and create two- and three-dimensional designs in Windy's image.

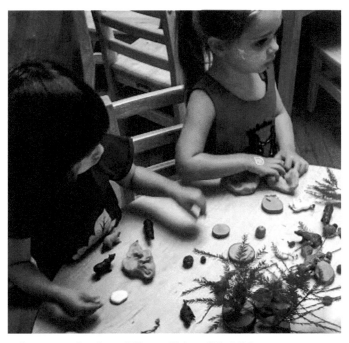

Using our collection of "beautiful stuff," children create representations of Windy and decorations for her branches.

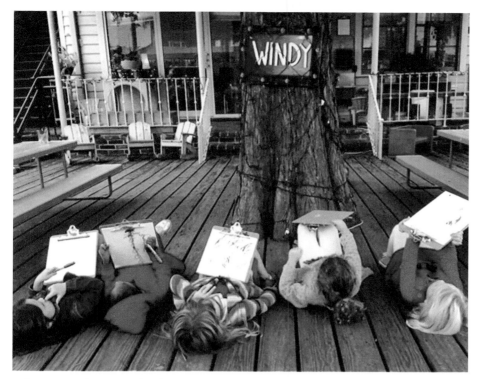

When one child lies on her back to look up into Windy's branches, everyone else tries out the position.

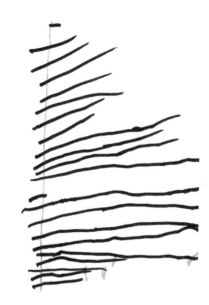

"These are Windy's branches! The green leaves are connected to the branches. That's it!" –Dixie

Our exploration of Windy is ongoing, day to day, season to season, year to year. It is the one exploration at our school that is a constant. Even our older students in tenth and eleventh grade know Windy as a friend. She has kept our school connected, questioning, wondering, and adoring nature since our beginning.

You don't have to go far to experience, study, and celebrate nature. Windy's presence gives our school an awareness of time, weather, seasons, shelter, different perspectives, and the fragility of our environment. Having Windy in our backyard is a powerful reminder of the importance of nature in our everyday lives. Windy's presence calms us, protects us, enriches us, and brings us joy. ◠

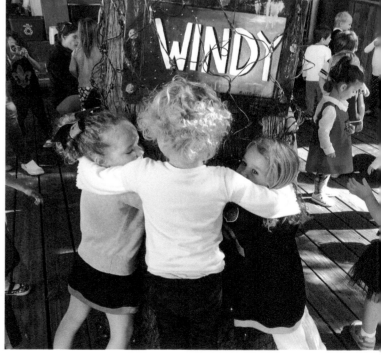

As an important presence in our school, Windy receives hundreds of hugs.

Setting Up for Exploration

CYERT CENTER FOR EARLY EDUCATION
PITTSBURGH, PENNSYLVANIA

Suzanne Grove, Studio Educator
Mary Moore, Assistant Director of the Younger Cluster
Barbara Moser, Studio Educator
Joella Reed, Early Childhood Educator

Cyert Center for Early Education is located on the Campus of Carnegie Mellon University in Pittsburgh, so we operate on a full-year schedule. During the summer months, we spend a lot of time outdoors with the children, in the community and also on our playground. Recently, we built an outdoor studio, in partnership with a university student. In this space and in our classrooms, we create setups for the children to explore. These thoughtfully arranged selections of materials and creatures from the natural world are designed to engage the children's curiosity and encourage exploration.

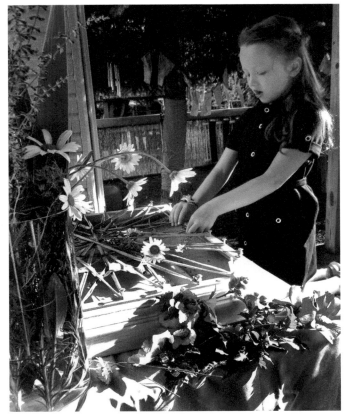

Teachers create a weblike structure on a frame and offer long-stemmed flowers. This fragrant, unusual weaving invitation grows into a beautiful group composition.

Creating great setups requires planning. What is the purpose of the setup? What are you hoping to learn? Will the exploration strengthen a skill and/or satisfy a curiosity for the children? Will it provoke more questions? How will it draw them in and sustain engagement? Setups can be used at different times for different purposes. For example, a setup can be created to support transitions, revisit prior experiences, or stage a new encounter. Our inventory of natural materials changes seasonally in a manner that ignites interest, value, and intrigue, always with attention to safety.

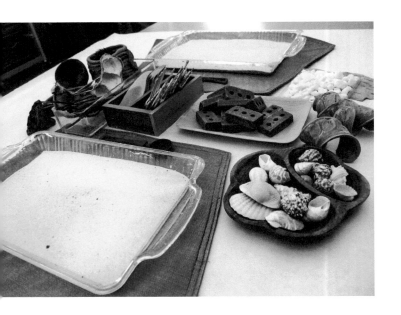

A setup with trays of sand is irresistible! Driftwood, shells, cinnamon sticks, bark, seedpods, and measuring spoons invite touch and exploration.

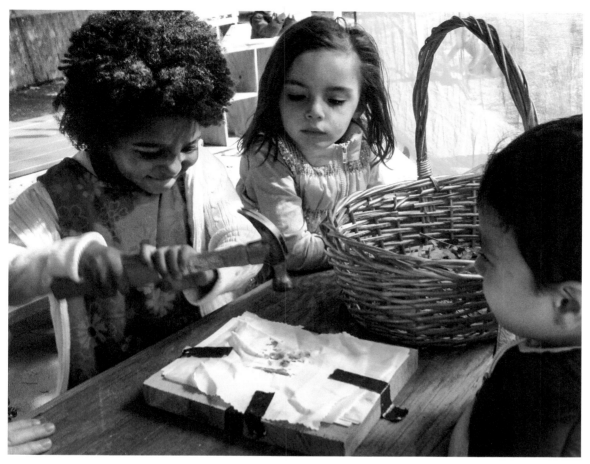

Olivia pounds flowers under a cotton cloth.

"Painting" on Canvas with Natural Specimens

One morning on the playground, we have the children gather "juicy" leaves and flowers from our garden. In the outdoor studio, they take turns arranging the items on a board. After securing a cloth over an arrangement, the children use a hammer to pound the specimen, and to their delight, the plants' colors transfer to the cloth. It is a surprise every time. This activity gives us a new way to think about color, its origins and effects. The transformation of plant color from a specimen to a canvas adds another dimension of awareness and intrigue to our study of nature.

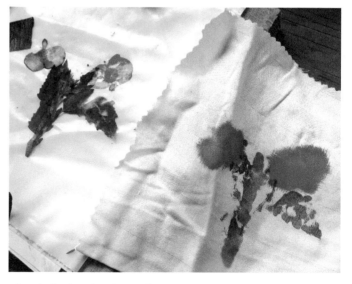

The cloth absorbs the moisture and color. "Paint" from nature offers the most amazing hues!

Something Old and Something New

When setting up an invitation for children to engage with natural materials, we often pair a familiar element with something new—whether it's a material, color, technique, or tool. By carefully documenting the children's responses, we uncover places where they have created new meaning.

A flower and stem resting along a corner of a purple canvas attracts attention. A paintbrush and luscious dollops of white, green, and purple paint are an invitation to step right in and get started. Some children create a representation of the specimen; others just enjoy making brushstrokes on the unusual purple canvas.

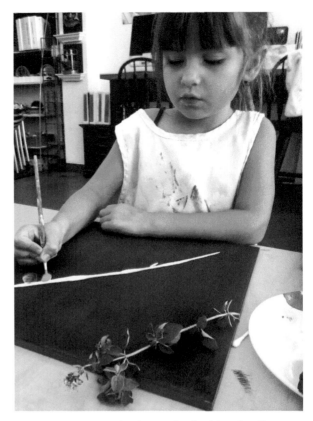

Novel colors paired with a familiar technique spark excitement.

An arrangement of gourds greets children as they arrive one fall morning. Colorful Sharpies and paper are at hand so they can begin creating immediately. Watercolors, offered later, renew excitement and expand the creative possibilities.

Children use magnifying glasses to explore the parts of plants.

To invite children to look again and record their observations, we set out flowers, markers, and printouts with an image of a vase.

Sometimes closely examining a specimen inadvertently releases an aroma, heightening sensory engagement.

Setting Up to Further an Investigation

In the spring when we are deciding what to plant in our garden, we overhear the children debating, *Are plants alive?* This discussion triggers a group investigation. We bring live plants and flowers into the classroom for the children to explore. They examine the specimens with magnifying glasses and draw them from observation. After researching, they come together as a group to discuss their findings.

We continue to look for new ways to offer natural materials to the students—and document their experiences. Through the years we have noticed that parents also value these activities for their children. Many families have contributed to our inventory of natural materials, adding to our knowledge and awareness. Parents tell us that our efforts have helped them make exciting connections when their children engage with nature outside of school as well. ◐

Getting Started

INCORPORATING AN ATELIER We challenged teachers to notice and use natural materials from their local environments. This inspired them to seek new ways to discover, collect, and organize materials and arrange classroom spaces. Sorting materials and placing them in containers reveals their individual characteristics and makes them easier to see and use. In this way aesthetics becomes an aid to learning.

PROVOCATIONS FOR LEARNING The teachers in these stories prepared provocations for learning rather than lessons by thoughtfully setting up inviting spaces for open-ended exploration. Handling materials, sorting them, playing with them, arranging and combining them in unusual ways, without the pressure to make something, is freeing. It is an effective way to become familiar with the qualities and potential of materials, and ultimately opens new possibilities for creation and expression. When open choice setups seem overwhelming for children, try limiting the array of materials or the creation space. A circle of black felt or a piece of cardboard makes a manageable platform for exploration.

INTRODUCING THE STUDIO The introduction to the studio sets the tone for the year. The studio teacher at Beginnings Preschool brings small groups of children into the studio. Shelves with containers of materials at the children's level are arranged in a beautiful way that makes them easy to see and use. By asking children to choose a container of materials to explore, she immediately helps them focus, physically engages them in the freedom of experimentation, and trusts them to handle the materials responsibly. In this way, even very young children intuitively learn how to use the studio.

DOCUMENTING THE PROCESS An important part of teaching is documentation—keeping track of children's learning in all curricular areas, as well as social-emotional growth and visual expression. Displaying children's drawings, paintings, constructions, and narratives, as well as teachers' notations and photos is a way to make learning and creativity visible. This visual way of documenting learning, guided by the atelierista, or studio teacher, is an essential tool for communicating to parents and sharing with the community the value of children's classroom time. It also sustains and provokes more in-depth work. The results of this process help guide classroom activities and approaches in a fluid and dynamic way all year long.

Like teachers looking together at photos and notes, children can appreciate the true impact of their experience by reflecting on their struggles and accomplishments.

Cultivating a Naturalist's Sensibilities

Study nature, love nature, stay close to nature. It will never fail you.

Frank Lloyd Wright

The Gift of a Garden

"If we save the garden, we save the world."

–Ameera

MYRTILLA MINER ELEMENTARY SCHOOL
NE WASHINGTON, DC

Jennifer Azzariti, Pedagogical Consultant
Courtney Daignault, (former) Lead Pre-Kindergarten Teacher
Linda Stanley, (former) Paraprofessional

Myrtilla Miner Elementary School is a public school in Washington, DC, that serves about 400 students, pre-kindergarten through fifth grade. Ninety-nine percent of the children receive free or reduced-price lunch. There is a strong sense of community in the neighborhood. The pre-kindergarten program is inspired by the Reggio Emilia approach.

Color Explorations

A three-day summer color and painting workshop inspired Courtney, the lead pre-kindergarten teacher, to carry her interest and enthusiasm for painting and the studio arts into her classroom. In addition to color and painting, this workshop focused on tools, techniques, and ways to organize and manage studio space.

Courtney decided that she would engage the children in setting up the various areas of the classroom right from the start of the school year. Mixing colors for the easel in the mini-studio became the first job of two or three children at a time.

Children mixed paint to match the colors of flowers they had brought in from home. Like scientists they experimented until they found a satisfactory match. Painting and drawing from life inspired the children to match the colors precisely, often resulting in an encyclopedia of greens, purples, blues, and pinks. When the first round of colors ran out, another group washed the cups and mixed more paint. While mixing colors, Maeve made a connection between school and home when she said, "I have a garden at my house." In fact, her family had a plot at the Wylie

With the support of a teacher, Mehki and James mix and test hues and tints of green to set out at the easel.

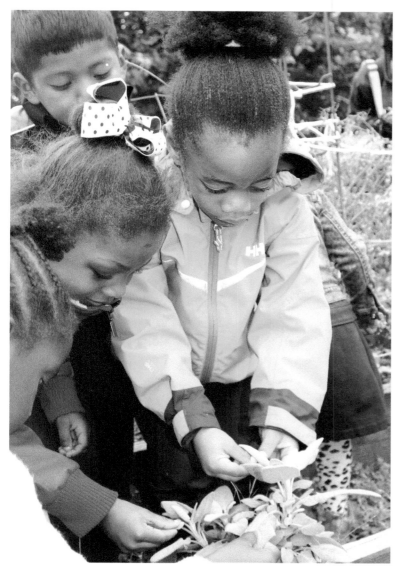

The first visits to the garden are about using the senses to discover what lives there.

Street Community Garden, an unused housing lot that was adopted by the neighborhood in 2002. After this revelation, her family invited the class to visit the community garden. The children had passed it often while walking, but it was something totally different to be invited inside!

First Visits to the Garden

The children were fascinated with the colors, smells, sounds, and feelings provoked by their discoveries. This was the first school experience for most of the students, and the teachers were surprised that they intuitively slowed down to observe, gently touch, and share discoveries with one another.

On one visit to the garden, the children took photographs of whatever captured their interest. They especially enjoyed experimenting with the zoom lens. It seemed that they were trying to get as close as possible to study the micro world. Back in the classroom, these photos served as references for drawing, painting, and sculpting—interpreting the garden through a variety of media. Each medium called on the children to use different materials, tools, processes, and skills.

As a result of their color mixing experiences, the children were more aware of the variety of greens in the garden. The teachers wondered if they could come to understand the cycle of life in the garden using these sensory and perceptual skills.

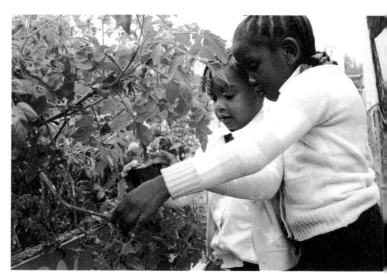

Cameras let the children zoom in on life in the garden.

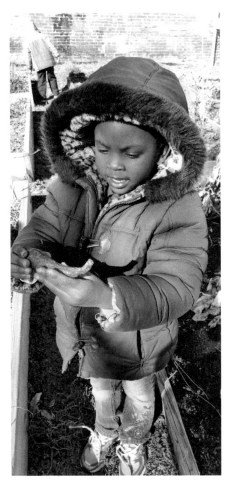

"The carrots got burned. They keep changing. I don't eat burned carrots." –Cy'tia

"There was nothing. It was empty." –Joseph

After digging in the winter garden, the children's drawings and paintings begin to feature roots.

Winter in the Garden

The children searched for signs of life when they visited the garden during the winter. They had a great time digging in the soil. They found lots of mud and brown things, which prompted them to scan the classroom for every kind of brown they could find. Even though Marielle observed, "Brown is a plain, plain color," they were able to identify many variations. And of course, when the children mixed colors, they often ended up with brown. They discovered shriveled vegetables, bugs, and roots, which prompted more research. The teacher hypothesized that the children understood there would be a moment of rebirth.

Exposed: The Secret Life of Roots, an exhibition at the United States Botanic Garden in DC, gave us a chance to look closely at many kinds of roots. On another field trip to the National Gallery, we explored how Impressionists used color in their work. When looking at a landscape painting by Vincent van Gogh, Lauren exclaimed, "That's my lipstick blue!"

Spring—and a Garden of Their Own

In the spring, the gardeners from the Wylie Street Community Garden, who had generously shared their expertise and the beauty of the space with the children throughout the year, offered the class their own plot. This became an exciting new area of study that involved the neighborhood community. The children used math skills to figure out how many of each tool the class would need, and literacy skills to compose letters to parents and gardeners requesting donations. A local hardware store donated supplies after the children made a list of what they needed.

There was so much to do—preparing the soil, figuring out what to plant and where, spacing the seeds, watering, and much more. Each task offered new areas of study and new materials to explore. It was difficult to wait, but finally spring arrived and sprouts began to poke out of the soil! After that, the children noticed new growth every time they visited the garden. Back in the classroom, they used a variety of media to represent their understanding.

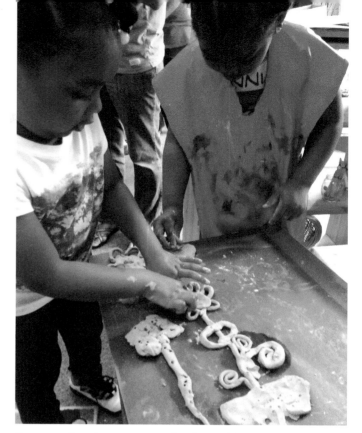

Representing the structure of a plant with clay, a child can mimic growth and evolution as she explores.

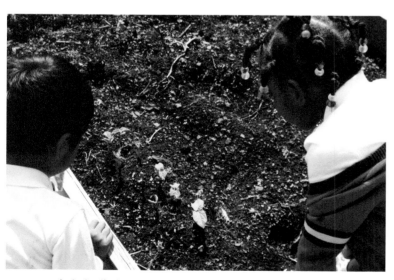

Little by little, sprouts appear, and suddenly it is spring.

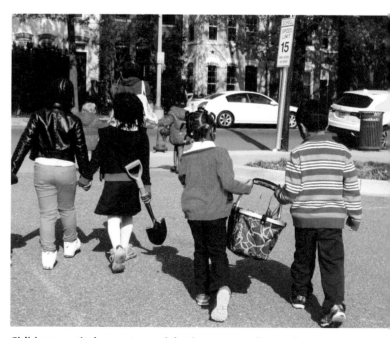

Children on their way to work in the community garden.

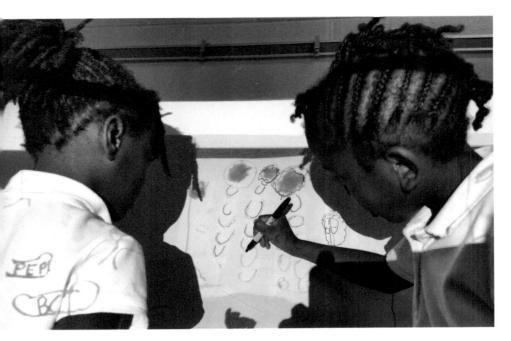

With the help of a projector, the children trace their drawings onto the mural board.

Mehki fills his drawings with color.

Disappointing News

On a walk just before the end of the school year, the children noticed a sign posted on the Wylie Street Community Garden fence. When they learned that the garden lot was for sale, they were upset.

We can't waste food, and if you put a building there, you can't plant more seeds to make food. –Marielle

We need to save the worms that live under the dirt. –Grayson

If we sell Wylie Street Garden, we are not going to plant no more seeds. If we put a building there, it will squish the worms, and they will die. –Cy'tia

If we save the garden, we save the world. The garden is the house for the butterflies and the worms. We want them to keep their homes. –Ameera

The class decided to make a mural to share their feelings about the garden and preserve memories of their experiences there.

A Community Effort to Save the Garden

There was a huge community effort to raise funds to purchase the garden, but ultimately the land was sold to a developer, and the garden was lost.

What remains from this experience is the joy the teachers, children, and parents shared in caring for the garden and the ownership they felt for this special place. It is clear through their conversations and their work that the children developed an intuitive understanding of the cycle of life through the seasons in the garden. Learning in the garden taught them how to care for their community and the environment. ∾

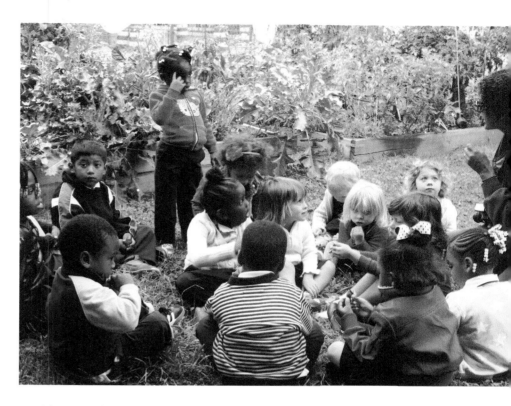

Working, drawing, painting, and singing in the garden, sharing it with the school and families, were meaningful outdoor experiences.

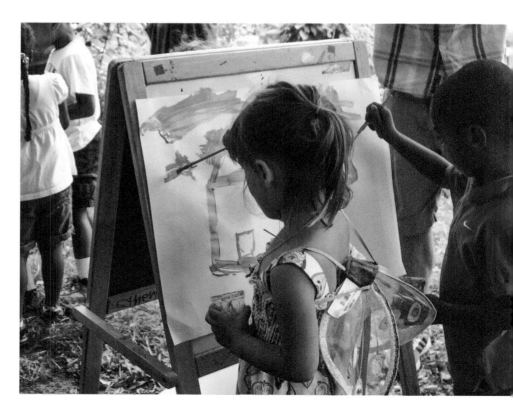

Naturalist Journal Covers

Constructing Letters from Natural Materials

CAMPUS SCHOOL OF SMITH COLLEGE
NORTHAMPTON, MASSACHUSETTS

Robbie Murphy, Second Grade Teacher
Bob Hepner, Studio Art Teacher

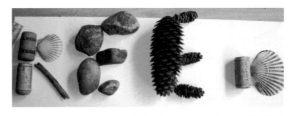

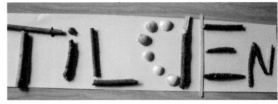

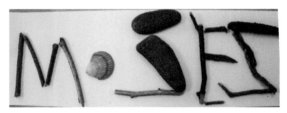

Large shells form the rounds of O, R, and D; small shells make the curve of a D; and twigs form the straight lines of M, E, and T.

At Campus School of Smith College, the kindergarten through sixth-grade classrooms act as a laboratory for the next generation of educators. As they interact with the children, teachers are designing and sharing innovative practices in education.

In the fall, the second-grade curriculum is framed by the question: What is a naturalist? The class reads picture books about famous naturalists such as John James Audubon, Rachel Carson, Wangari Maathai, John Muir, and Henry David Thoreau. Then the students share their ideas about what these individuals had in common: a passion for being outdoors, a fascination with noticing and recording observations (they all carried journals), a habit of collecting, identifying, and cataloging nature, and a curiosity to understand more.

After they identify what naturalists do, the students try out those behaviors. Our first field studies teach the students to interact with nature in respectful ways that optimize their ability to gather information. We discuss how to notice things, and they practice their "predator walk" to minimize the sounds they make.

Going on an Alphabet Hunt

In preparation for gathering observation notes, the students make naturalist journals. The class prepares to go for a walk outside to collect materials that remind them of letters of the alphabet. As a group, they study the alphabet and discuss the shapes and lines that make up each letter. With these forms fresh in their minds, the students venture out and collect. Back in the classroom, they sort the materials. Again they refer to the alphabet and note how the natural objects translate into the component parts of letters as grouped in the Handwriting Without Tears curriculum. Sharpening their eyes as naturalists supports their work to make careful, legible letter formations.

Collaboration between the Classroom and the Art Studio

Collaboration is an important part of how we work as a school. What we do in one discipline is reinforced in other areas of learning. In this case, our study of letters through natural materials extends into the art studio.

The studio art teacher introduces the idea: "This whole year, the teachers will encourage you to view yourself as a naturalist—someone who is interested in learning about the natural world, observing habitats, and finding connections between plants and animals. You are going to begin by writing your name using the natural materials you collected." The teacher goes on to say that their name sculptures will be photographed and will serve as the cover for the naturalist journals they will use all year.

Before they begin their name sculptures, the students are encouraged to notice the qualities of the natural materials:

> Which forms are symmetrical?
> Which are curved? Which are straight?
> Which could be used to create a chain?
> Which natural forms are already a line?
> Which could act as lines?
> Which could act as shapes?
> Which have textures or repeated markings?

The children practice forming the letters of their names on a strip of paper. They get a sense of scale and move materials around until they are evenly spaced.

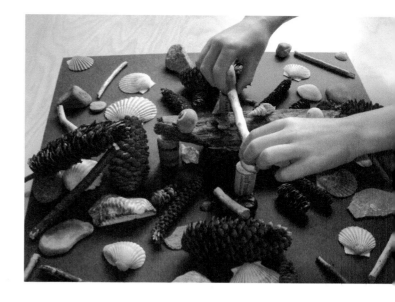

Designing as a Team

After photographing the name sculptures, the studio art teacher gives each table one black 18-inch square of construction paper as a design space. Then he asks each group of second-graders to arrange the natural forms to create a design. The groups must create the design by working together.

They brainstorm approaches, such as:

- Starting from the center and working out.
- Starting from corners—maybe opposite corners—but they must agree on how to proceed.
- Creating a symmetrical design.
- Creating a radial design.

This exploration is a starting point each year for second-graders. Making naturalist journal covers allows us to integrate literacy skills and art with the study of the natural world. The children learn that there is a difference between being outdoors as a scientist, as a naturalist-scientist, and for recess. As students transition from outdoor-oriented summer experiences to the classroom, they welcome opportunities to be outside. On our campus, nature provides a valuable learning space—for the children and the teachers. ∾

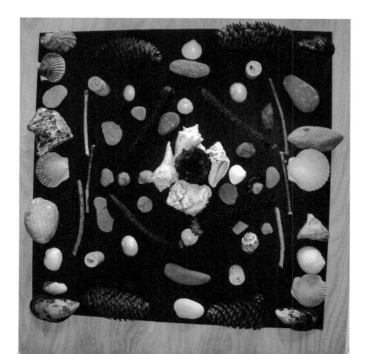

Building an Outdoor Classroom

SABOT AT STONY POINT
RICHMOND, VIRGINIA

Melanie Nan, Fourth Grade Teacher-Researcher

Sabot at Stony Point in Richmond, Virginia, is a Reggio Emilia–inspired progressive school for preschool through eighth grade. Sabot is surrounded by rocky woodland in a community aptly named Stony Point. The fourth-graders and I have always taken frequent excursions into the nearby forest. I have learned from my students how the outdoors can become a transformational classroom. This is my story.

A Provocation to Slow Down and Listen

Fourth-graders thrive on social interaction yet often find it difficult to listen to each other. As a provocation to slow down and truly listen, the class reads *The Other Way to Listen* by Byrd Baylor and Peter Parnall. The children are inspired to experiment with the quiet kind of listening described in the book. They want to find out if they can really hear the rocks. On our next forest excursion, each student picks a spot—lying on a rock, sitting near the creek, or perched up in a tree—and listens. Expecting that they will tire of this exercise after just a few minutes, I am surprised when half an hour passes in blissful silence.

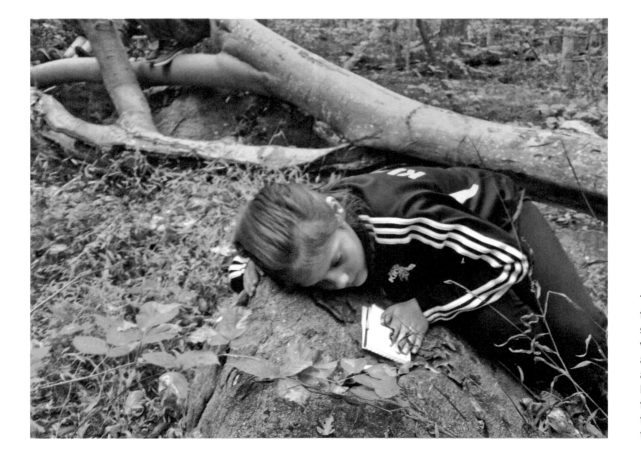

The students find places to settle down with space around them and quietly listen. They use field journals to record their thoughts.

Back in the classroom, the students share their reflections. The silence has given them time to come up with poetic writing.

Trees seem to dance for you, and water seems to say hello. –Griffin

I could hear the wind whispering to me. –Ryan

The rain is trying to snuggle me. –Sophia

I heard the water trickling past and the sound of things scurrying in the underbrush, the wind whispering to the trees, the leaf falling onto the ground, and the cars roaring in the distance. I heard the wind and the trees speaking back and a slow trickle of rain. –Abigail

It made me feel calm, peaceful, and quiet. –Ella

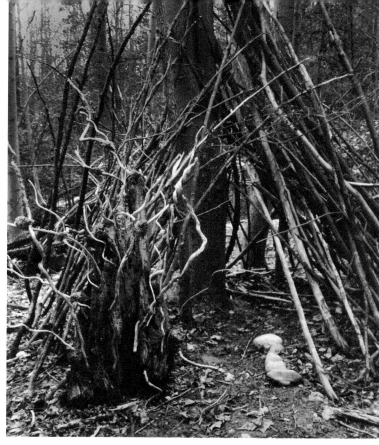

Livie is deliberate in her emphasis on beauty. She accessorizes the entryway of her shelter with round stones and a sculpture made from curly vines and vivid green moss.

Creating the Outdoor Classroom

The quiet listening experience is a revelation. I realize that my fourth-graders crave the quiet and calm of the forest and actually have a need to be outside. To support this need, I challenge the students to build an outdoor classroom using only materials foraged from the forest. They eagerly begin construction, working alone, in pairs, and in small groups, sharing strategies and trading materials. As they build, I notice them coming together with a sense of focus. As the students work, they discover building techniques using large branches and trees. Their shelters grow more complex as they reinforce walls and roofs.

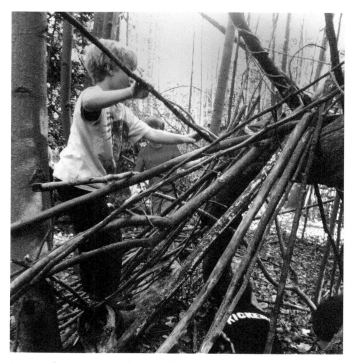

Later, when I share this experience with colleagues, we realize that the children used an ancient building technique to create wikiups or lean-tos.

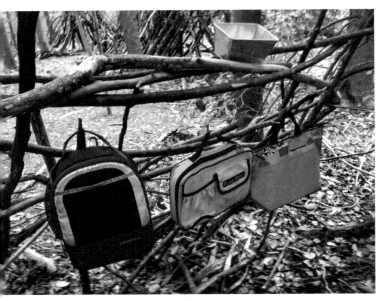

Eliza and Abigail weave sturdy branches to create a wall, then add a rack for holding lunch boxes.

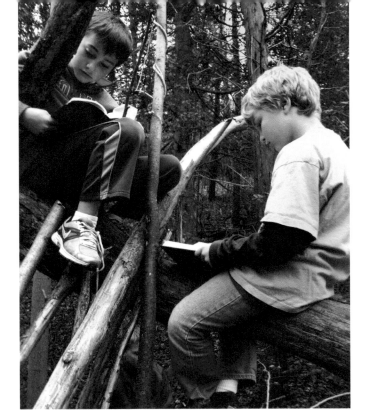

"It feels peaceful because no one is talking but Mother Nature." –Griffin

I am delighted to see the students not only choosing materials for their practicality and availability, but also for their beauty. They construct furniture and other decorative elements. As they make this place their own, it is clear that they value it for its aesthetic qualities as well as its functionality as a place to learn. This forested area becomes our outdoor classroom for the remainder of the year. The fourth-graders spend time here every day.

"How About a Triangle?"

After the fourth-graders finish building their village-style outdoor classroom, they want to create a communal space. As they begin to plan, Abigail says, "I don't honestly want to do a circle. I've had too many circles." I assume that the children are rethinking the need for a group space, so I am surprised when Abigail continues, "How about a triangle?" They are not rejecting the collaborative experience but rather making it their own.

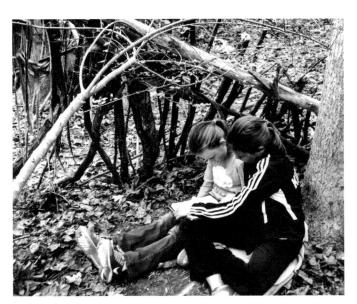

"I like the outside space better than the inside because there is nobody squeaking chairs or having side conversations. It makes me feel free. It can calm me, and I feel like I can do anything without getting interrupted." –Sophia

Creating the "triangle" is a truly transformative activity for the class. Whereas the children had worked alone or in small groups to build their workspaces, in this task they finally collaborate as a group, a feat they have never accomplished before. The task they have set for themselves can be done no other way.

A Mathematical Approach

The fourth-graders use a mathematical approach to determine how much space they will need. They decide on an equilateral triangle made of 15-foot-long logs. That way each child will have 3 feet of space.

The fourth-graders use a model to plan their triangular discussion space.

They choose a site and measure out the space.

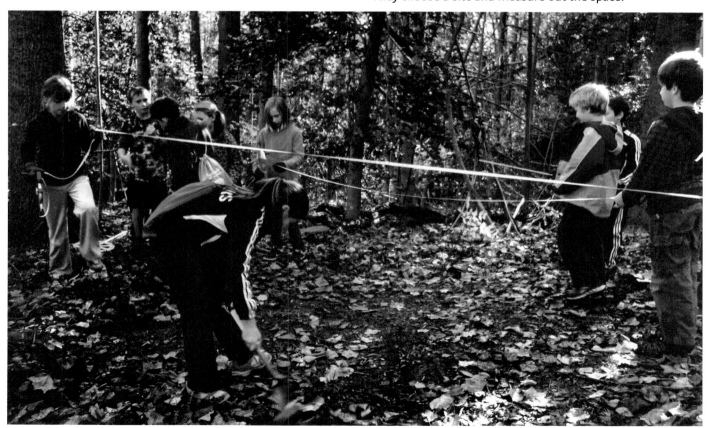

They look for fallen cedar logs and measure 15-foot sections.

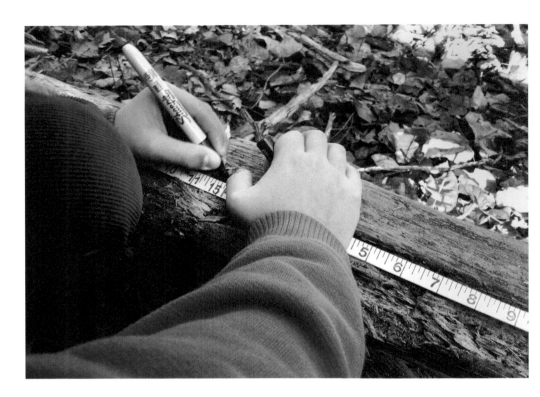

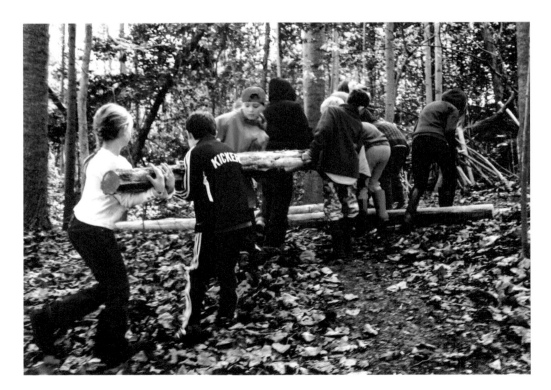

"Move back, back, back. Down. Slowly."
–Chris

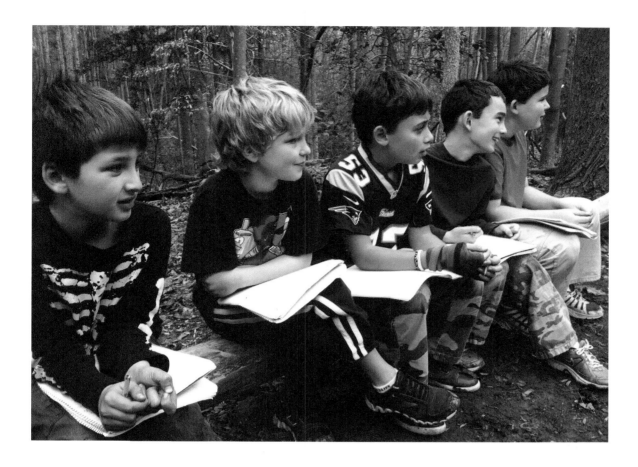

Five on each log, the fourth-graders make use of their triangular discussion space.

After the logs are cut, the real transformation in the group occurs. Because the logs are so heavy, every child is needed to carry them. I notice some individuals taking on new leadership roles. Clearly, when the students have a reason to collaborate, they can.

As children grow, social complexity increases. Being outside, slowing down, and learning to really listen helps them develop more subtle sensibilities and qualities. By capturing the words of the children and photographing them at work, I could not only see what was important to them, but also possible pathways forward.

Since building the classroom, I have thought a lot about the power of learning outside. It was not just this one class that craved the outside environment; that yearning is within all children. Subsequent fourth-grade classes have recreated life as 18th-century Powhatan people. They have gathered data about the vast variety of animal and plant species that live on our campus. They have measured the height of trees, and chosen to use the outside environment as inspiration for poetry, artwork, and mathematical problem-solving. Perhaps Theo sums up our experience best:

The outside classroom makes me feel more focused and better than the inside classroom. I feel more at home outside. It is not as loud, pushy, obnoxious, and distracting as the indoor classroom. I like that we are surrounded by natural resources and that we have space. It is cold, but who cares. ❧

A Scientific Study of Mushrooms

LANDER~GRINSPOON ACADEMY
NORTHAMPTON, MASSACHUSETTS

Amy Meltzer, Kindergarten Teacher

The children don't pick or even touch the wild mushrooms they find. Instead, they photograph the specimens.

At Lander~Grinspoon Academy, a private Jewish day school for kindergarten through sixth grade, we spend a lot of time talking about fungus. And why not? Fungi are amazing! They pop up overnight in strange and often overlooked places. They are complex and beautiful. They are easy to find in the fall in New England, when the kindergarten classes typically delve into a science topic. In addition to the wild varieties that are native to the area, a wide assortment of edible mushrooms can be purchased at supermarkets, farmers markets, and Asian markets. As nature's recyclers, they teach us important lessons about conservation, transformation, and life itself.

Our class begins our study of fungus with a field trip to nearby Arcadia Wildlife Center to search for wild mushrooms. The four- to six-year-olds learn about mushrooms' important work clearing the forest floor and helping to turn dead matter into rich soil. The children take photographs of the specimens they spot.

Looking Closer

In the classroom, the children observe the most well-known variety, the white mushroom—the kind that come wrapped in cellophane in the supermarket. I emphasize that we can only eat mushrooms we buy at a market, because some types can make you very sick, and you have to be an expert to know the difference. The children practice working like scientists, documenting what they notice in their science journals.

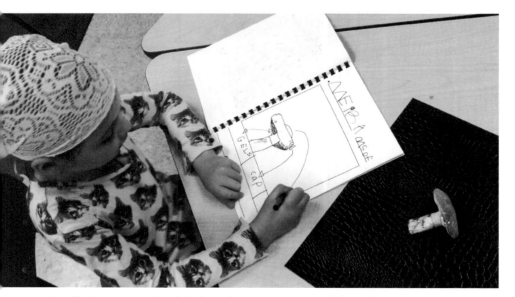

The kindergartners do their first close observation of the white mushroom without any prior information—just drawing what they see.

A Field Trip to the Farmers Market

After becoming acquainted with the white mushroom, the class visits the New England Wild Edibles booth at the local farmers market. Thanks to some generous contributions, we are able to purchase five varieties of mushrooms to deepen our study.

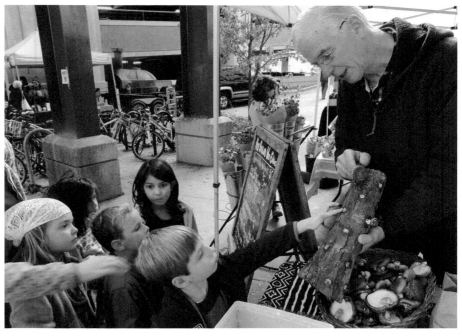

Choosing mushrooms at the farmers market.

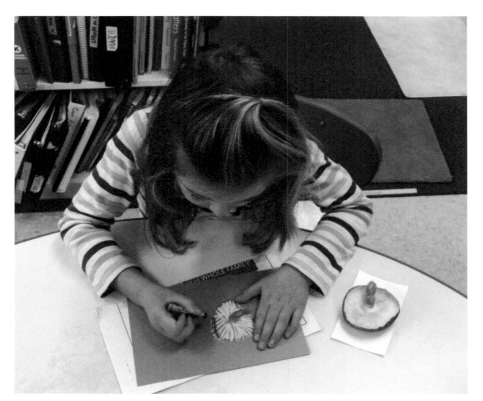

Using oil pastels on neutral-colored construction paper helps the children notice subtle tints, tones, and shades of brown.

Gaining Understanding

The students use books about mushrooms to identify the parts—cap, gills, ring, stalk/stem, and mycelia. They enjoy looking closer at their specimens using magnifying glasses and a standing magnifying lens. A digital microscope, bought with a gift from the parent-teacher organization, is a popular choice for observations. It displays magnified images on a computer screen. The children are highly motivated to record what they observe.

The kindergartners become acquainted with their specimen by representing it in a variety of media. With each new medium,

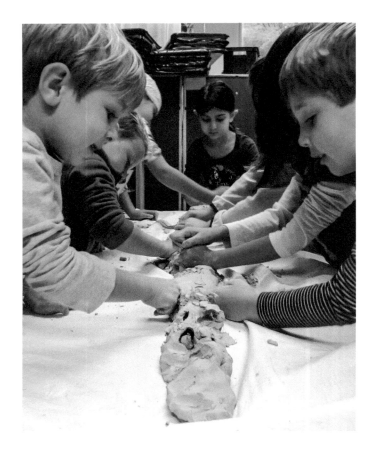

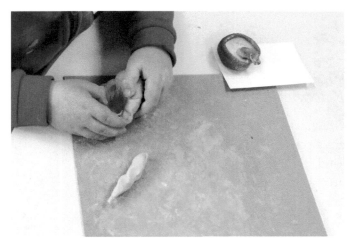

The children need time to explore, manipulate, and become reacquainted with clay and its qualities before attempting to model their mushrooms.

they notice different qualities and record them. While using pencils, children notice linear details. With oil pastels, they experiment with the subtleties of neutral colors, try blending colors, and think about what direction to fill in spaces. With clay, they study the three-dimensional form and the textures of their mushroom. The children especially enjoy translating their observations into clay. I give them time for free exploration before asking them to try to recreate a form.

After looking on the Internet at images of some of the most beautiful mushrooms on the planet, the children design mushrooms that feature the parts of a real mushroom—but with imagined colors, shapes, and designs.

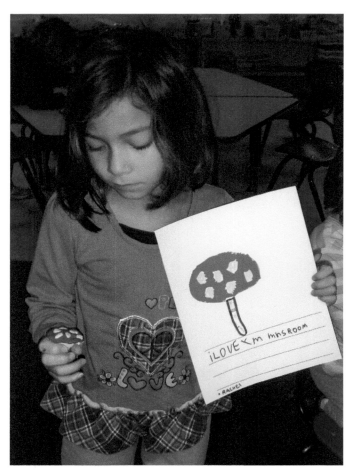

Rachel's imaginary mushroom features real mushroom parts—cap, gills, ring, stem

Applying Scientific Knowledge

Green leafy plants that grow from seeds are a common topic of exploration in kindergarten. Mushrooms provide a great contrast in terms of how they grow, reproduce, and get their "food." Toward the end of our mushroom research, a grandmother visiting the class asks the children what they have learned.

> *If there is a rotten-down tree, mushrooms can grow on rotten-down trees. There are little tiny spores that you can't see. If they fall on something rotten, they could grow into a mushroom. Mushrooms do not need sunlight. –Zachary*

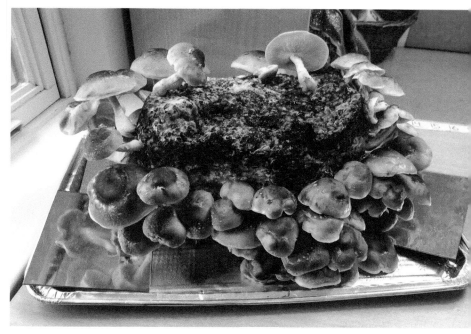

Our "class pet"—a shiitake mushroom-growing log.

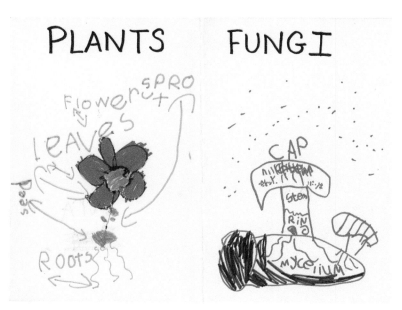

Mira draws her understanding of the difference between plants and fungi.

> *Mushrooms do not have seeds—well, they have something like seeds in the cap, but they're tiny, like molecules. The mushroom gets nutrients from dead things, like dead leaves, but a plant gets its nutrients from the sun and soil. You cannot see mushrooms most of the time until they grow up—like on a dead log—kind of like a sprout. –Gabe*

Our mushroom study keeps growing and evolving. Since yeast is part of the fungus family, the class watches a video that describes yeast cells as "yeast monsters" that burp carbon dioxide. We are now trying to catch and grow some wild yeast in a mixture of flour and water to create our own sourdough starter. I have found that posting the children's activities on a classroom blog is a way to bring parents right into the classroom and help spark conversations at home. I now realize that we could probably spend the whole year learning about fungus! ❧

Autumn in the Ravine

Discovering the Subtle Variations of Leaves

THE BISHOP STRACHAN SCHOOL
TORONTO, ONTARIO, CANADA

Kerri Embrey, Grade One and Lead Teacher
Amanda Humphreys, Lead Teacher
Kathleen Grzybowski, Lead Teacher

The Bishop Strachan School in Toronto is Canada's oldest day and boarding school for girls in junior kindergarten to twelfth grade. Each year we experience the seasonal response to the temperature change, and each year we are in awe of what nature shares with us. On this day, the beautiful autumn weather calls to our first-grade class. We set aside our indoor plans and take the opportunity to visit the ravine near our school.

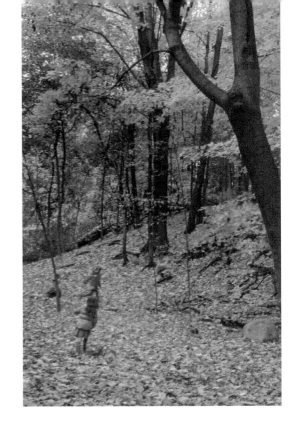

Reaching the ravine, the children quiet down, move slowly, and get close to the beautiful carpet of leaves.

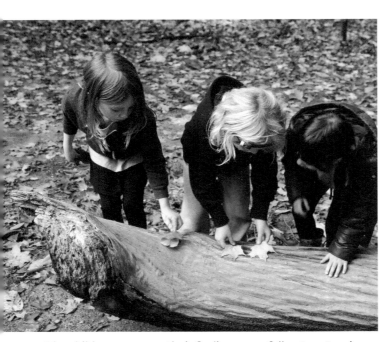

The children compare their findings on a fallen tree trunk.

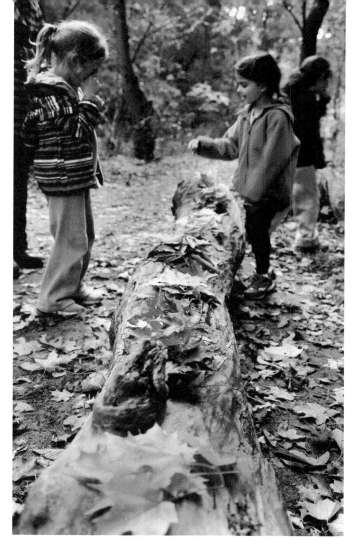

The first-graders enjoy piling leaves into families of color.

Debate ensues about how to organize the leaves. The students find a place for each one, in unspoken agreement that they all belong. One group selects leaves that are darker in color and arranges them by the intensity of their hue. Discovering leaves of varying sizes becomes another small group exploration.

As the students work, their strategies reveal different ways to organize, order, and stabilize the materials. Working in the ravine, surrounded by abundant materials and immersed in the natural environment, makes this group effort more purposeful and transformative than if the leaves had been collected and brought into the classroom to be explored. Working outside with natural materials is a direct way of knowing about the environment. Bringing natural materials indoors makes them precious again, as they hold memories of the outdoor experience. ॐ

As the children walk through the ravine, quietly taking in the beauty, they begin to notice and explore the subtle variations and qualities of the leaves rustling underfoot. Through this process, they are building a deeper relationship with the natural environment.

So much happens when you are outside with children. Rather than trying to document everything, we challenge ourselves to slow down and capture just one moment of the experience. We observe the students' energy and enthusiasm as they select and collaboratively arrange the leaves in chromatic order on a log.

One group arranges leaves by their hue. As their selection grows, they use pebbles to keep them in place.

Cultivating a Naturalist's Sensibilities

MINDSET OF A NATURALIST Teachers use many strategies to get children ready to explore outdoors. Once children are prepared, the teachers can step back, allow nature to be the teacher, and trust the children to find and invent their own ways to explore. Watching carefully and capturing the children's words and images then becomes the teacher's task. Documenting can reveal interests and interactions, and show teachers new and deeper pathways to pursue.

CROSS-CURRICULAR ACTIVITIES Developing children's curiosity about the natural world can provoke interest and persistence in science, math, language arts, and more. When they spend time in nature, children can learn quiet listening. They can record their thoughts and observations through journaling, poetry, drawing, photography, and sculpture. The atelierista, or studio teacher, can support the creative investigations of both the children and teachers with materials, tools, studio processes, and documentation. Collecting, measuring, planning, and constructing are ways to get children engaged physically as well as mentally.

IN-DEPTH INVESTIGATIONS Long-term investigations encourage deep understanding and a sense of ownership. When children are engaged in a long-term project, it's easy to meet learning standards in science and math. Splinter projects often emerge as investigations deepen. Unusual collaborations sometimes form as interested individuals work together to research. Long-term projects allow parents, and perhaps even the community, to become involved. Field trips with strong connections to on-going studies can expand investigations, enlarge the children's world, and make use of local resources such as museums and wildlife centers, as well as laborers, construction workers, and craftspeople. Adding an imaginative option to any investigation allows learned facts and information to be applied in unusual ways. New explorations, stories, and exciting artwork often grow from these activities.

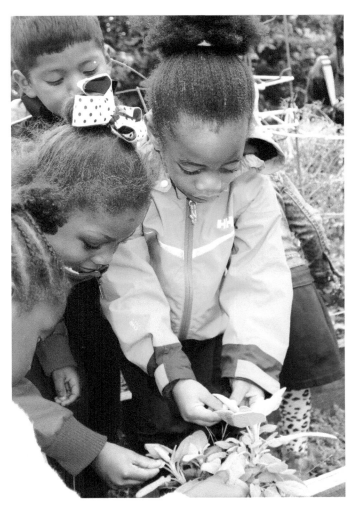

So often we tell children, "Just look, don't touch." But touching and smelling things is a vital part of understanding.

Your Unique Place

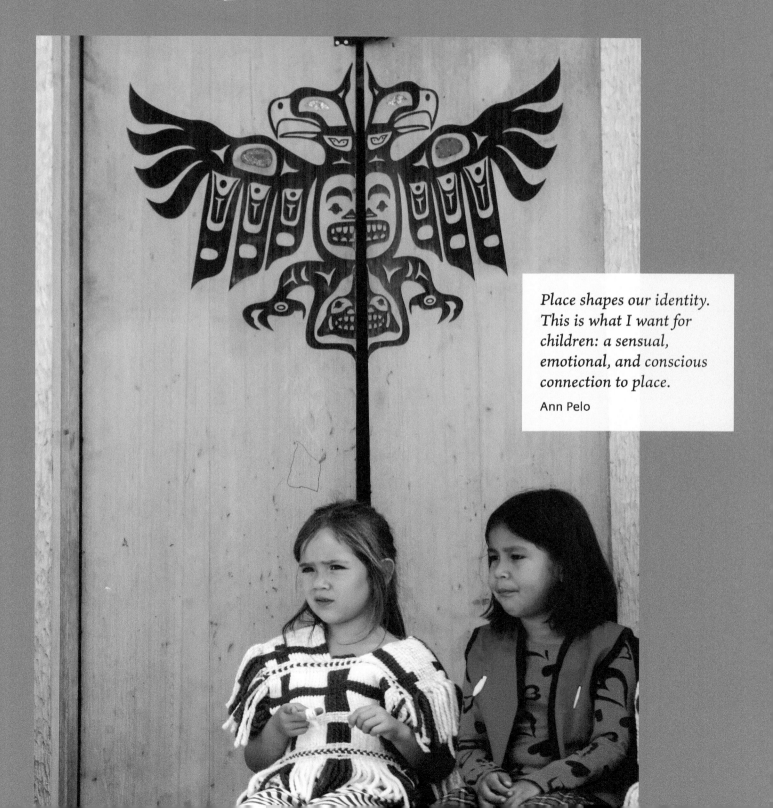

Place shapes our identity.
This is what I want for
children: a sensual,
emotional, and conscious
connection to place.

Ann Pelo

Reviving Our Indigenous Traditions

MEM7IMAN CHILD DEVELOPMENT CENTRE
SHÍSHÁLH NATION, SECHELT,
BRITISH COLUMBIA, CANADA

Maggie Chow, Atelierista
Lenora Joe, Director of Education, Early Childhood Educator

The shíshálh Nation community is located on the Sunshine Coast of British Columbia, Canada. Our nation, like many others, continues to be affected by the trauma of Canada's residential school system—a program intended to assimilate Aboriginal children into white culture. From 1820 to 1970, approximately 150,000 children (who are today's few remaining elders) were removed from their homes and communities, forbidden from speaking their native languages, and severely traumatized and abused. Many Aboriginal languages, traditions, and oral histories have suffered or were lost as a direct result. Even today, we see the effects of this cultural trauma in our young people, who exhibit higher than average rates of learning disabilities, learning delays, and depression. Our public middle and high schools have low graduation rates.

To address this problem, we asked ourselves: How can we teach our children more effectively? How can we bring back our traditions, our language, and the

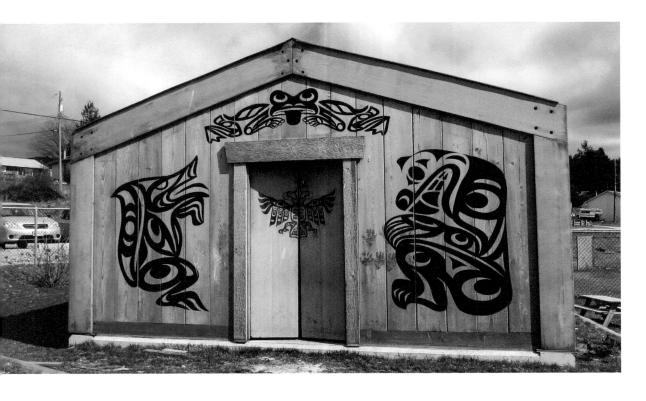

This mini-longhouse, next to our child development center, was custom-made by a local artist. The door bears a double eagle, the symbol of our shíshálh Nation.

wisdom of our ancestors? We set a goal of honoring our culture and working to revive our almost lost language as part of everyday learning. Lenora Joe, our education director, was called in to address the issues. A member of the shíshálh Nation, Lenora was raised by her grandparents in a traditional home. She identified the source of the low graduation rates to be a lack of basic educational foundations related to literacy. She pointed out that to create major change, beginning with high school or middle school was too late.

Reinventing Our Approach to Education

After extensive research, meetings, and discussions, the community concluded that we needed to reform education starting with our youngest children and their families. Parents and the community would establish strong relationships right from infancy and create a learning environment that responded to children's innate curiosity, intelligence, and desire to explore. We began researching approaches to early education that better reflected our cultural heritage.

Our location offers many natural environments to explore.

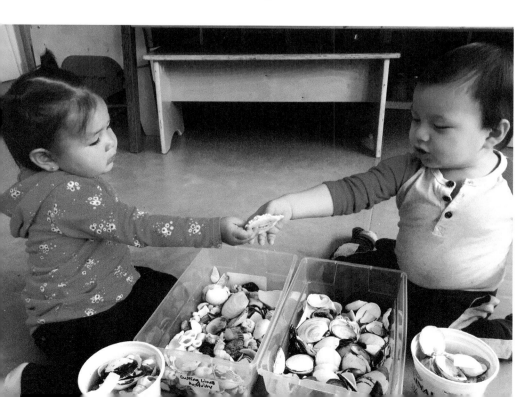

The shíshálh Nation reformed education starting with its youngest children.

49

When we return to the classroom, the children represent their discoveries in a variety of media.

The Reggio Emilia approach resonated with us. Of all the methodologies we studied, it is the most similar to the holistic and visual-spatial way our elders were once taught. Traditional ways of learning encouraged children to explore at their own pace while teachers observed children's strengths, listened to their comments and questions, and nurtured their interests. We were seeking a new path to culture-based learning that honored our beautiful history, language, and social context, and fostered positive indigenous identity.

On the beach, it may seem as if there's nothing to do, but the children find endless wonders to explore.

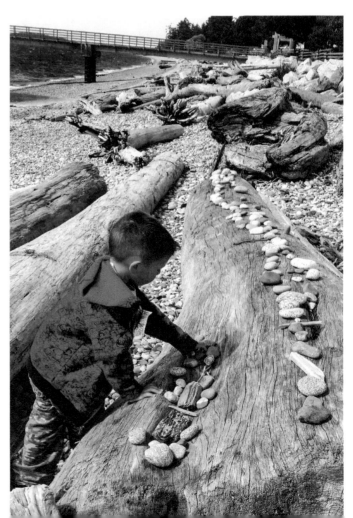

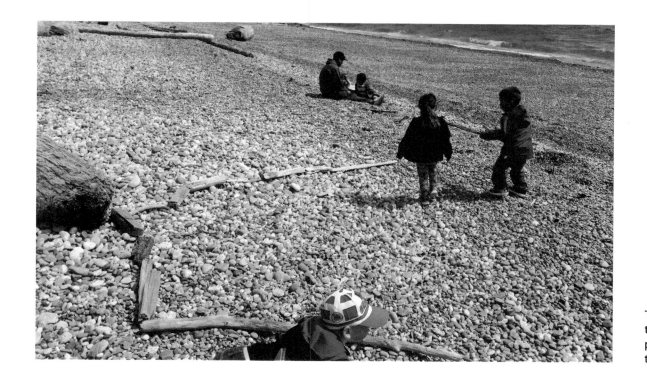

The beach is the children's playground and teacher.

Environmental Design

We built the mem7iman Child Development Centre for infants to five-year-olds, inspired by the Reggio Emilia approach, on the foreshore next to the forest. Communion with nature was built in by design, with a geothermal heating system and green roof. Here we have created an outdoor education program with a focus on exploring our natural environment. Starting and ending each day outside makes our students more successful.

The mini-longhouse at our school was custom-made by a local artist. For our people, the longhouse is a traditional building where learning and ceremony occur. On the door, the double-headed eagle, the symbol of our nation, is surrounded by the wolf, frog, and grizzly bear symbols of our clans. Children learn that it is important to enter the longhouse with an open heart, to hang up criticism and judgment, and to take off any "blindfolds." The longhouse is not a playground. Rather it is a place of respect for storytelling, dancing, and discussions.

The children learn to be patient and quiet as they watch for wildlife. They are keen observers of natural phenomenon and the ever-changing weather, sea, and sky.

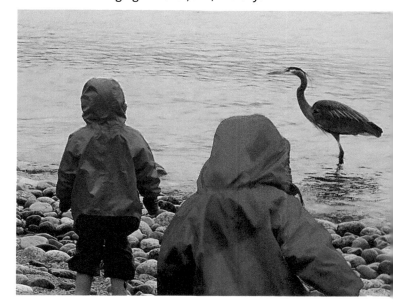

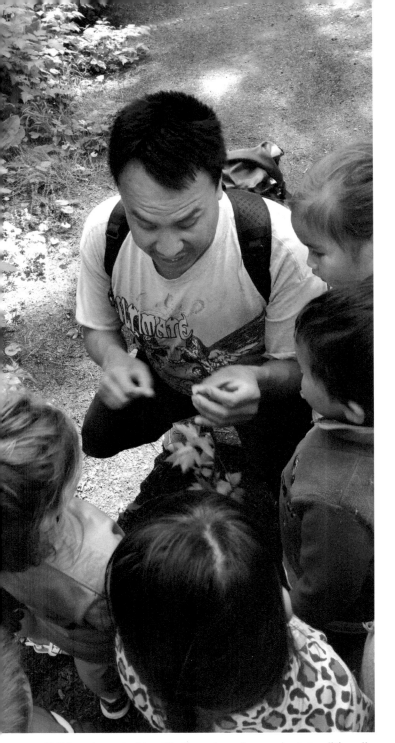

Children learn to identify the salmonberry plant, traditionally used for food and medicine.

Exploring Our Ancestral Land

The children love exploring the beach. They play and build with cedar logs, tree stumps, sticks, stones, shells, and sea creatures that wash up on shore. On trail walks in the forest, we explore plants like the salmonberry, traditionally used for food and medicine. The children learn to be gentle, to say a prayer to the plant, and to take only what they need. Back inside the center, the children represent their discoveries in a variety of media with the support of an atelierista.

Salmon is one of our most important traditional foods. Every year we watch for their return to nearby streams. Members of the shíshálh Nation visit our school and use ancient techniques to prepare and cook the sacred fish on the beach. Then the whole school shares this traditional meal.

The salmon is sliced, mounted on cedar sticks, and smoked. The children help by collecting firewood.

Honoring Our Traditions

Every June in Canada, we celebrate Aboriginal Day. For a two-week period, around eighty canoes visit First Nations communities. During the festivities, children witness special ceremonies and join in on the celebrations while traditional canoes from many Aboriginal nations cruise the coast. The children appreciate the quiet concentration of anticipating their arrival. Everyone meets at the beach and waits to be invited up by the elders. Tents go up and ceremonies, including singing, drumming, and storytelling, begin. It is a very important and emotional time.

Sketching helps the children look closer at these rare sights.

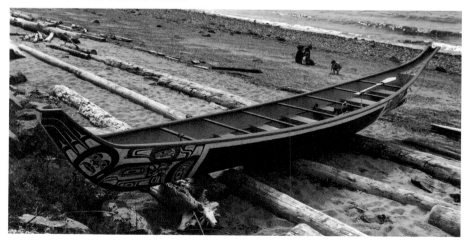

In celebration of Aboriginal Day, dozens of canoes visit our beach.

Katiyanna arranges cedar strips traditionally used for weaving.

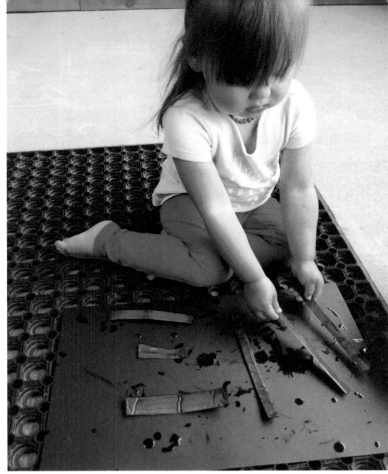

Classroom shelves display natural and traditional materials.

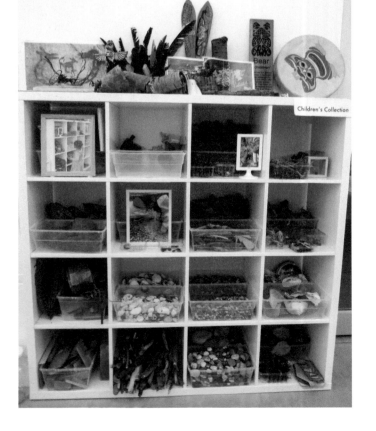

Bringing Traditional Materials Indoors

The beach, gardens, and nearby woodlands are filled with treasures for the children to collect. In the classroom, they explore traditional materials, especially cedar, used by our people for carving, building, canoes, clothing, and baskets.

Shelves in the classroom contain traditional materials, cultural objects, and the children's collections. There are feathers from many birds, including the eagle. The double-headed eagle, the symbol of our nation, reminds us to always look forward to be aware of what we are doing, while at the same time looking backward, never forgetting our past. An elder tells the children, "An eagle flies overhead, and the feather drops. You should keep it forever because it brings good luck and good health."

Reviving Our Language

Over the past forty years, our elders, working with a linguist, have documented the shashishal-hem language. The result is a dictionary of 11,000 words. When our elders visit the children, they speak only the Sechelt language. The staff at mem7iman use shash-ishalhem words with the children in everyday activities such as washing hands, eating, cleaning up, and hanging up jackets. They learn colors, numbers, and greet-ings like "good morning" and "goodbye." In these ways we carry on our traditions, simul-taneously looking forward and backward. ॐ

Eagle feathers and cedar cuttings await exploration by the children.

Cedar branches projected onto a screen create a magical wonderland in our dramatic play area.

Constructing an Appalachian Alphabet

An Arts and Literacy Project

GILES COUNTY, VIRGINIA

Lynn Hill, Art Teacher and Volunteer,
 Giles Early Education Project

Giles County, Virginia, is located in the heart of Appalachia. It boasts 92 square miles of the Jefferson National Forest, 52 miles of the Appalachian Trail, 37 miles of the ancient New River, and hundreds of miles of trails and back roads that lead to waterfalls, fishing streams, and endless natural wonders. Our old-growth forests are home to white-tailed deer, bobcats, eagles, weasels, otters, foxes, black bears, and over seventy bird species.

Unfortunately, Giles County is also one of the most impoverished areas in Appalachia. Recent poverty statistics show that 54 percent of our children under six live in a household that makes an income of half the federal poverty level. The Giles Early Education Project (GEEP) was launched in 2012 to address local poverty through the children. In the past six years, GEEP volunteers have worked to increase the number

Aerial photo of Giles County by Alisa Moody.

The Giles County Appalachian Alphabet

A Appalachian Trail
B Buttercups
C Corn
D Duck Feathers
E Eggs
F Ferns
G Green Beans
H Honey
I Insects
J Jewel Weed
K Kudzu
L Lilies
M Morel Mushrooms
N New River
O Onion Blossom
P Pumpkins
Q Queen Anne's Lace
R River Rocks
S Snake Skin
T Tomatoes
U *Ursus americanus*
V Violets
W Worms
X eXoskeletons
Y Yellow Things
Z Zucchini

by The Lunch Bunch with Love and Support from Lynn Hill 2015-2017

of preschools in the public school system, bring books and art experiences to hundreds of children, and advocate for teachers and guardians. We collaborate with the public schools and their USDA-sponsored program, which provides free summer lunches to children and adults in the county.

Each day during the summer months, the school system sends buses out to the far reaches of the county to pick up children and bring them to one of two school cafeterias, where a hot lunch is waiting. Each site serves approximately 600 free lunches per week. Afterwards, the children can take part in a variety of activities provided by GEEP, such as our library, block area, writing station, and beading.

Most popular by far has been the art studio space. Together we work with fiber, wood, clay, paint, paper, adhesives, and many natural materials. During studio

L is for Lilies. Q is for Queen Anne's Lace. V is for Violets.

sessions, children sit side by side, sometimes sharing chairs if we don't have enough. While their hands are busy and their heads are down, the materials work their magic and the children begin to talk, sharing stories of their lives that include their fears, struggles, and confusion. The intimacy at the studio table gives the adult volunteers an opening to offer resources and support. In this way, we can begin to counter poverty with aesthetics.

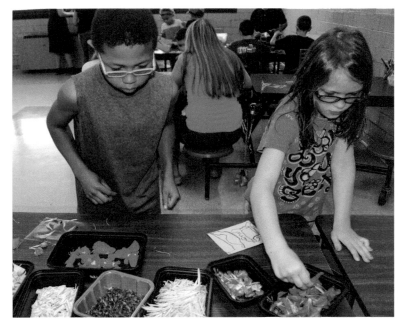

Children used flowers to create the first letters of the Appalachian Alphabet.

Make the Problem the Project

The Appalachian Alphabet Project grew out of my desire to address the literacy issues I saw in many of the children. Often the younger children in our program were disinterested in books, and it was not unusual for the eight- to seventeen-year-olds to tell me that they couldn't read. Some were upset by it, some were embarrassed, and others had just given up trying.

The children seemed inspired to address this problem. Working as a mixed-age group solidified their sense of community and commitment to the project. Taking inspiration from our beautiful surroundings, we decided to create a special alphabet. The goal was to form each letter using an item beginning with that letter. So tomatoes were arranged into the letter T, and zucchini formed the letter Z. As they brainstormed, the kids delighted each other with silly suggestions.

I know ... P can be for poison ivy! –Chris

Yeah, and C can be for copperhead! –Emily

Right away we realized that some of the letters were going to be more elusive than others, but that challenge made the kids even keener observers of the natural world. The collaborative hunt for letters enthralled them, and every day their powers of observation grew.

We started with flowers. The children brought in bouquets from gardens and roadsides. They touched and explored the petals, examining shape, color, texture, structure, and fragrance. They observed similarities and differences and marveled at the beauty in such small pieces of nature.

"I" Is for Insects

Figuring out a way to represent each letter raised many challenges. It opened up possibilities for new kinds of materials to explore and use to craft the letters. After deciding that "I" would stand for insects, my colleagues and I collected field guides and reference books from the library so the children could see the wide variety of insects in our county. These images, paired with beautiful studio art materials, offered one at a time at key moments, motivated the children to design, sketch, sculpt, and paint specimens. They took note of parts of the insects they had not noticed before. They were mesmerized by the colors, body shapes, numbers of wings and legs, and length of antennae. The older kids took pictures with their phones of the insects they encountered in their yards. They eagerly showed them to one another, then used the reference materials to make identifications. It was a wonderful way for us to acknowledge the vast assortment of creatures right outside our doors. Suddenly, the kids were budding naturalists!

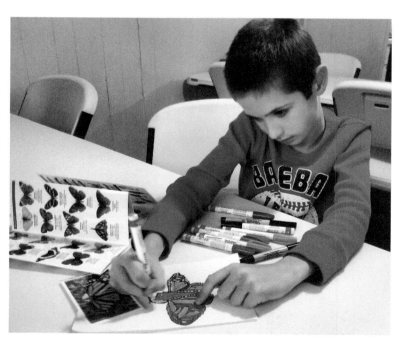

The children were motivated to consult field guides and the Internet for details to add to their insect drawings. They were developing research skills without even realizing it.

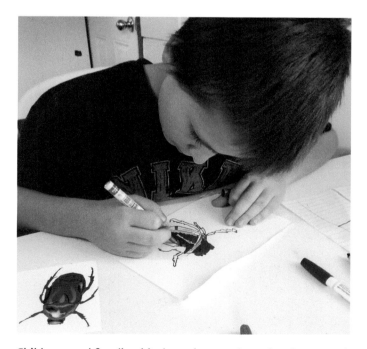

Children used fine line black markers to draw the shapes and details. Then they added color with paint pens.

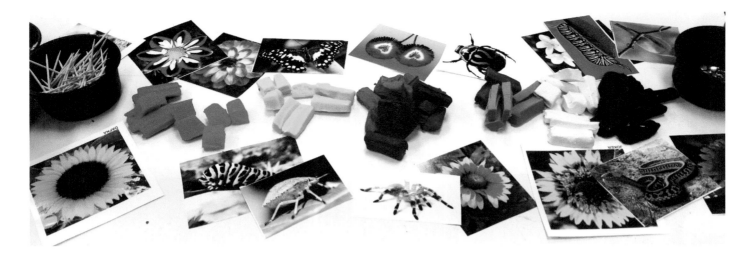

After exploring the new medium, the children began creating insects and flowers in three dimensions.

A setup of flower and insect images with colorful synthetic modeling clay proved irresistible.

The Gift of Time

Letting go of the need to complete the alphabet project in a prescribed time frame let the volunteers relax and allowed the children to move at their own pace. Slowing down let us linger on compelling aspects of the experience. Giving ourselves time was exhilarating for both children and adults. The children gained a greater sense of ownership when deadlines weren't guiding the process. As a result, after days spent drawing and painting insects and flowers, I surprised the children with a three-dimensional art medium—modeling clay.

After three summers of concentrated effort by the children, the Appalachian Alphabet was finished. GEEP had posters of the alphabet printed, which we proudly display.

Another Use for Our Alphabet

Recognizing, as GEEP had, that our kids were struggling with academics, a local church rented a trailer in the trailer park where many of the children live, and set up an after-school tutoring and community center. This is a place where the children can go right after school for a snack, help with homework, and fun. GEEP was invited, and this was where we found another use for our alphabet. We cut out the letters of the Appalachian Alphabet, and the children used them to practice letter recognition and spelling.

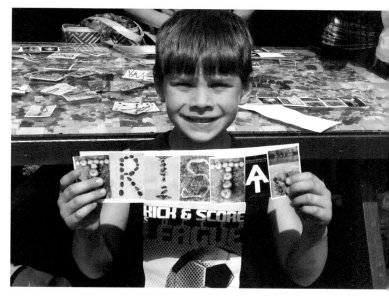

Tristan, age five, "writes" his name for the first time. Our unique alphabet helped him with beginning letter recognition.

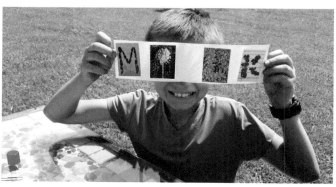

A New Interest in Learning to Read

It was exciting to watch the children discover a new interest in reading when it was introduced in such a novel and fun way. Their public school teachers informed us of the children's growing skills and heightened self-confidence. The children continued to brainstorm unique ways to use the alphabet. They are currently working on versions of Scrabble, Go Fish, and matching games.

The Appalachian Alphabet project became a way to honor our unique environment. Through it, the children of Giles County learned that the natural world around them is absolutely fascinating. Nature is mysterious, surprising, beautiful, unpredictable, and free—and it has the ability to educate and heal. ᦰ

Johnny needed to study for a spelling test and found using the alphabet letters to be more fun than traditional rote methods of practicing. "I think I'm gonna get an A on my test!" he told us proudly. And he did!

A School's Response to Hurricane Irma

L'ATELIER SCHOOL
SOUTH MIAMI, FLORIDA

Simonetta Cittadini, Founder and Director

In Miami, hurricane season is expected every year, but for the state of Florida and for L'Atelier preschool, Hurricane Irma, arriving at the beginning of the 2017 school year, was a natural catastrophe. Most of the state evacuated. Power was out for over a week. Winds ravaged homes and buildings and shredded trees. Many ficus trees were ripped from the ground by the wind, landing on homes and in streets, creating chaotic blockages.

The children's drawings after the storm communicate the profound impact the events had on them. They tell of hasty evacuations in the middle of the night,

"The flood was pushing the trees, and the trees fell … I saw it in my TV. The water was all around the buildings." –Mateo

flooding, and the destruction of their city. They also express the children's astonishment at the destructive power of nature, and empathy for the living things in its path.

The Aftermath of the Storm

At our school we lost one special tree, planted eight years ago in memory of a dad who had passed away in a tragic plane crash. The tree fell in a particular position. We wanted to believe that it was to save the other trees from falling on our school.

So many trees were lost—including ones we had come to know and love, name, and study in the nearby park. Everywhere in the city, people were cleaning up and hauling away debris. It all seemed a terrible waste. L'Atelier's teachers met outside the school to begin cleaning and clearing. We decided together that our friends—the spike tree, rainbow tree, palm tree, and others—were not going to leave our school.

"On the news I saw the flood. It was taking the cars and pushing them away." –Krizia

"I was in my house, and I did not have lights. The strong wind came outside my house, but it did not come inside. The colors are for the wind not to destroy my house because colors are more stronger than wind." –Fabiana

"The hurricane was knocking [things] down. The storm blew the trees. This is a rainbow tree. It is from Mexico. It's supposed to bend. The purple hurricane was trying to knock down that one." –Grayson

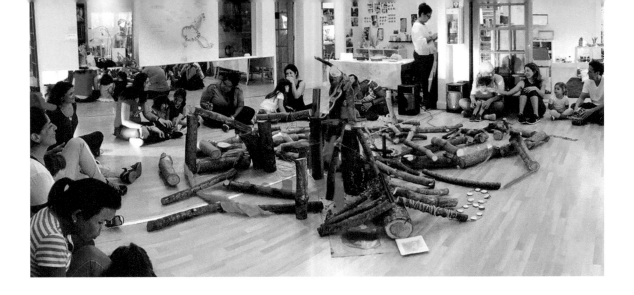

Children and their families welcomed the trees to their new home inside the school.

Giving the Fallen Trees New Life

The trees would become part of our school. We began to cut them up in many shapes and sizes. Some pieces we cut small so the children would be able to lift them. We sanded rough edges. We made mulch and sawdust. Figuring out different possibilities for cutting the trees became a creative and healing activity for the teachers. As soon as we had cleaned up outside the school and the park, L'Atelier opened its doors to the community. We offered power and a sensitive space for anyone who wanted to spend the day. We had no agenda. We played soft music and sat together around the fallen trees. The children interacted with the tree parts, piling them up, making new combinations, and creating little streets and pathways. When children started to interact with the fallen trees, we saw their perspective on what had occurred in our city.

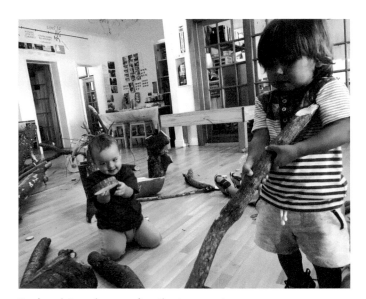

Ezgi and Angelo examine the tree parts.

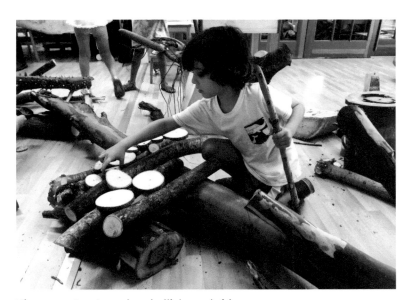

Tiago constructs and embellishes a bridge.

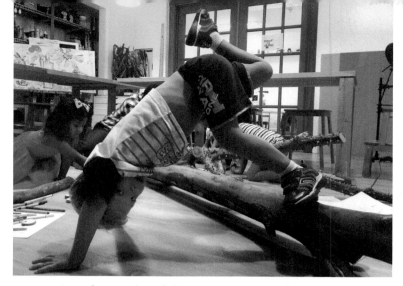

Ioannis uses the rainbow tree as a strong base.

Zaylee mimics the posture of a stump in our atelier of light and color.

A Catalyst for Movement

As they explored the trees, children found inventive ways to relate to them. We observed new kinds of movement—rolling, stepping, jumping, curving one's body around a tree part, and swinging. The children also experimented with sound and weight. Children "brought trees back to life" by standing parts up and adding new movements and body actions to their dances and dramatic play. Our atelier of movement built upon the actions of the children. Instead of the storm being the end of the trees, they had found new life in our school.

Emma lovingly embraces a stump.

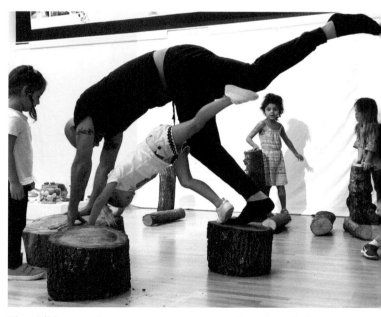

The children explore new movements, and teachers follow their lead.

In the past, our special trees shaded and delighted the children, but their towering height made them inaccessible. Now they could truly interact with them. They could explore the size, weight, texture, color, and shape of tree parts. They could observe the rings with magnifying glasses and under a microscope. Our science curriculum expanded! Many new possibilities with wood opened up.

Sun and Water Glue

As the children explored the trees inside the school, we noticed that the older students were trying to reconnect the parts. They wanted to help the trees stand up again. They experimented with wire, yarn, knotting and macramé, and lace. The children tried mixing materials to make glue. We overheard them theorizing about the need for a special glue, filled with love and power, to reattach parts and help the trees stand again.

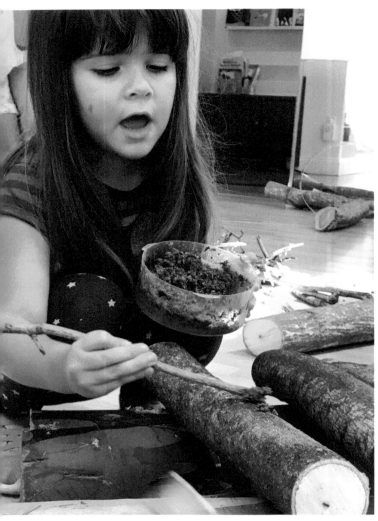

Valentina tries to heal the tree with her "glue."

Sara and Fabiana work together to reconnect tree parts.

"Sun and Water Glue" by Tiago. "Sun and water will give all the vitamins."

"[This is] the glue of the sound of the heart of the tree. The tree sends messages through sound waves, through the rings of the tree. In order to reattach, they [the rings] have to be the same. They have to sing the same song." –Mateo

As the children worked, we took note of their drawings and recorded their poetic musings.

It has to be special glue—glue that is heart with power that connects you.

When you are connected, you go back to nature.

The special glue is inside the heart. It is really, really sticky. It is beautiful glue.

We realized that when nature is endangered it is innate in young people to try to help—not as a task set up by the teacher but from a desire to do something about it. After Hurricane Irma, our children showed us a sense of responsibility for nature that teachers at L'Atelier listened to. ❧

Sharing a Personal Interest in Fiber Arts

LINCOLN SCHOOL
PROVIDENCE, RHODE ISLAND

Giovonne Mary Calenda, Early Childhood Studio Teacher

For the past twenty years I have been the early childhood studio teacher at Lincoln School, a small, independent Quaker school in Providence, Rhode Island. My days are filled with joy and discovery as they are shared with the three- to six-year-olds in our Reggio Emilia–inspired program. I am a fiber artist and have lived on a sheep farm most of my life.

We use wool from my sheep to explore a variety of fiber arts.

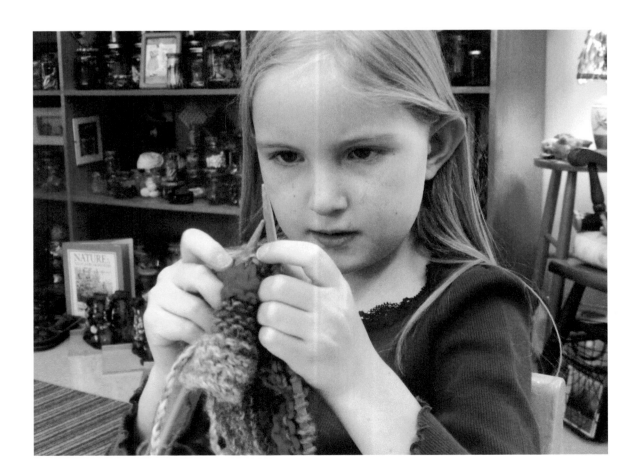

As Kate knits, she repeats an age-old rhyme to keep track of the four-step process:

Under the fence
Catch the sheep
Back we come
Off we leap

A ball of wool from my sheep.

Felting

The felting process is magical. Using only their muscles, natural handmade soap, and water, the children can transform raw fleece into felt. The three- and four-year-olds make felt balls to play with or string together as necklaces. Pre-kindergartners and kindergartners use felting techniques to create ocean-scapes and fairy meadows for dramatic play. During their study of the ocean, the kindergartners fashion wool to resemble beach stones and use actual stones to shape woolen pouches for their treasure collections.

My mother taught me to knit, spin, and weave at an early age. This immersion in the world of fiber and textiles has shaped me as an individual and as a teacher.

The fiber arts are so sensory in nature that children's interest is engaged immediately. With a simple pull and twist of fibers, children begin the transformative process of spinning. The fiber arts require perseverance and patience and help develop fine-motor skills and hand-eye coordination. Boys and girls are equally awed and delighted by the opportunity to create something aesthetically pleasing, potentially useful, and uniquely their own.

The children are always eager to learn about life on my farm, hear stories about my sheep, and experience the wonders of wool. Parents have graciously shared textiles and family heirlooms with our classes, enabling us all to appreciate fiber arts from Argentina, China, India, Korea, Mexico, and Turkey. Many experiences in Lincoln School's studio are related to the fiber arts. Here are a few of them.

With a little soap, water, and friction, raw fleece transforms into felt.

Dyeing Wool

One of the most precious gifts of living in New England is the opportunity to experience the beauty of nature through the seasons. Early on in my fiber explorations, I became interested in the world of color gleaned from gardens, meadows, and fields. I love sharing these traditional dyeing methods with the children.

The Natural Dye Fiber Workshop is an annual kindergarten experience that brings to life the relationship between art and science. We learn about textile traditions of various cultures, with a focus on weaving and dyeing with natural materials. Using books on dyeing and botany as reference, we take walks on campus, identifying native plants such as goldenrod, pokeberry, and dandelion. We gather baskets of fallen acorns from our oak trees, and marigolds and fennel from the edible garden. Our school chef saves avocado pits and skins for our experiments, and children bring in items from home.

In the studio, the children help prepare the dye baths, and together we dye skeins of wool from my sheep. In addition to using local materials to achieve natural colors, we employ traditional dyestuffs from around the world. Creating an indigo dyepot with the older children is always an evocative experience.

The dyeing process always interests and excites. I use Kool-Aid dye with the youngest children. The sweet-smelling, vibrant colors have an immediate and whimsical effect on the wool.

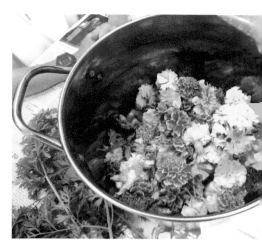

A pot of marigolds is prepared in the studio to dye woolen skeins.

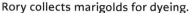
Rory collects marigolds for dyeing.

Solar Dyeing and Fermenting

Recently we have been experimenting with solar dyeing and fermenting in our greenhouse. This gradual and truly natural method of creating beautiful colors teaches us to be patient and offers us the opportunity to explore decomposition. It also enables the children to participate in every step of the process. The beautiful jars of botanical specimens are enchanting.

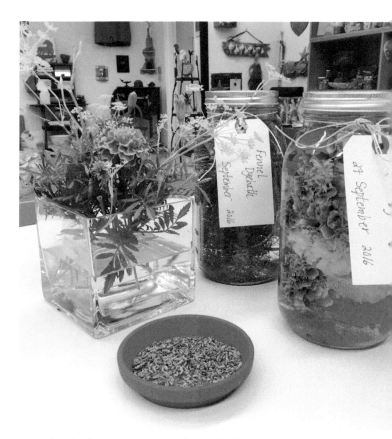

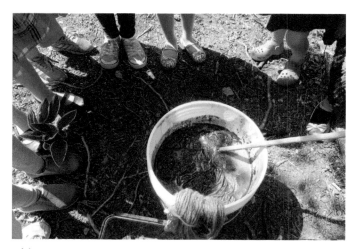
Older students take turns stirring the indigo dyepot.

For solar dyeing, we pack specimens in jars and let the sun and time do the work.

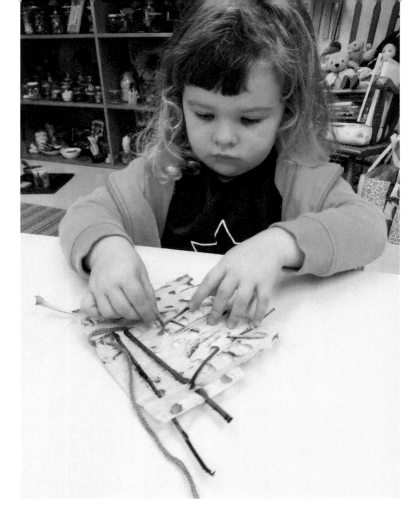

Using amate bark paper as a base, Madeline weaves with autumnal-colored yarn and tree treasures gathered on walkabouts.

Weaving

I am always on the lookout for interesting materials for weaving and creating looms. Our repertoire includes canvases, metal hardware cloth, lobster nets from Maine, and the always plentiful supply of empty tissue boxes. Mexican amate bark paper works great for younger children. It is stiff and easy to hold. It comes in large sheets, which I cut into pieces of a workable size. I like the way it offers the opportunity to weave in all directions.

Being involved in all stages of the fiber preparation gives the children a lot of control over their artwork. They learn how to blend their own unique palettes using carders. The drawn-out fibers are then used for weaving or spun into yarn.

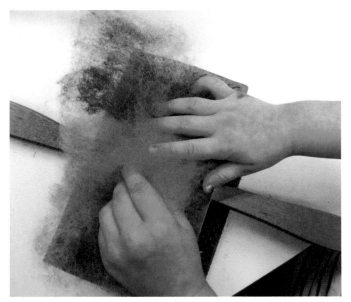

Blending colorful wool fibers using a carder.

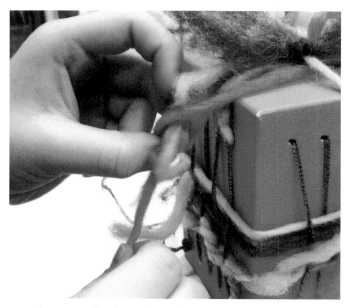

Weaving around a tissue box with Kool-Aid-dyed yarn.

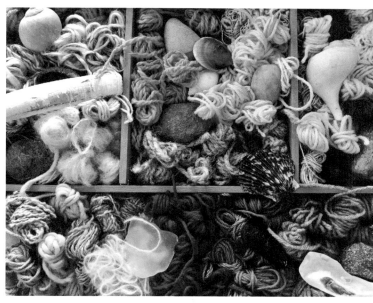

Choosing colors from our collection of dyed yarns triggers memories of shared experiences that continue and grow from year to year.

For tissue box weaving, I create the warp on the boxes and invite the children to select a box and create. The techniques that emerge are as unique as the children themselves. Some embellish each box side separately, while others prefer to wrap all the way around. They explore over and under patterning, twisting, knotting, and bow-tying.

I have been delighted to witness the children's pleasure in exploring and creating with fibers, native plants, and natural materials.

It is my hope that these experiences germinate the seeds of environmental stewardship and love of the earth, as well as a sense of place in our children. Joy for learning—and ultimately for life itself—is at the heart of the studio experience. ❧

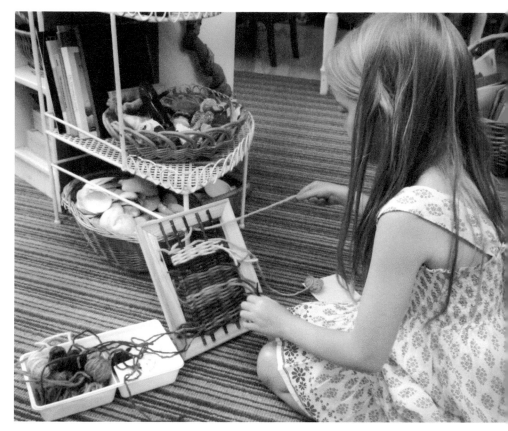

The children use dyed wool to design tapestries on handheld looms.

73

An Island Beach Experience

Site-Specific, Three-Dimensional Design

THE BISHOP STRACHAN SCHOOL
TORONTO, ONTARIO, CANADA

Mary Murray, Kindergarten Teacher
Heather Evelyn, Kindergarten Teacher
Kathleen Grzybowski, Lead Teacher

Toronto sits on the shores of Lake Ontario, which is an inextricable part of our sense of place. Even so, the lake and our natural environment can be forgotten amidst the urban landscape as we go about our daily life at The Bishop Strachan School. We asked ourselves how we could make our unique place a more integral part of the learning experience.

Designing begins with exploration.

In the Nature Center

The Nature Center in our kindergarten classroom offers children the opportunity to interact with natural materials indoors. It features a wide array of rocks, sticks, shells, pine cones, and bark. The children also contribute materials.

Early in October, collaborative designs begin to appear in the Nature Center. We notice kindergartners are spending time experimenting with the placement of materials. Intentionality, pattern, and symmetry are common threads in the sculptures they create. As groups of children share their work and their thoughts with the class, the activity becomes contagious. Everyone wants to create a design. By designing with natural materials, the children are developing a stronger connection to nature and to the environment. This is evident in their stories, associations, and poetry.

The Sun by Tasafa

The rocks are a circle.
The sticks are the fire.
The pine cones are standing.
The shells are curling.
The sticks are stretching for the sun.

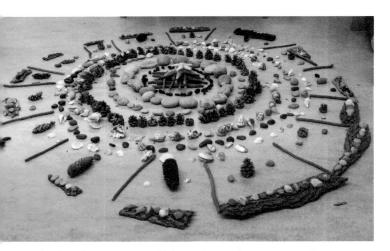

In the classroom, a collaborative sculpture expands as more children make additions.

As we watch the kindergartners designing in the Nature Center, the teachers begin discussing our city's natural resources. We decide to take a field trip to a nearby island to deepen the children's connection to our local environment.

An Accessible Escape within the City

Just off the harborfront in downtown Toronto is a collection of small islands. After a quick ferry ride, we find ourselves in another world, surrounded by woods, marshland, and beautiful beaches. On the shores of an area called Wards Island, we invite the children to expand upon the designs they created in the classroom. They were inspired by looking at books of Andy Goldsworthy's work. Goldsworthy uses natural materials from the landscapes he visits to create site-specific sculpture that reflects a relationship between the materials and their surroundings. The children naturally

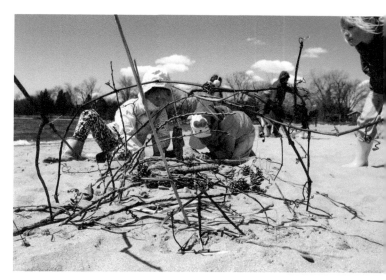

An organic artwork grows out of the sand.

begin to collect, organize, and display materials they find on the beach.

When working on the island, nature is a true partner; the children's work is in collaboration with the environment, rather than imposed upon it. In retrospect, we notice the sensory nature of interacting with a range of delicate, unusual, and irregular materials. The children take time to observe the qualities of familiar and new materials. They challenge themselves to make connections and build in three dimensions. They are always moving, but they are also interacting and negotiating with clear purpose.

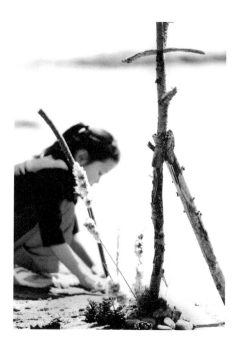

Inspired by Andy Goldsworthy's work, the children leave their sculptures for others to discover.

On the island, the children exhibit a respect for the materials, which has grown out of their work in the Nature Center. As their relationship with natural materials develops, so do their relationships with one another. They share the satisfaction of having been the initiators of this adventure, and of creating something beautiful that couldn't have been done alone. Now we see place/environment as a provocateur and collaborator. The teachers at The Bishop Strachan School let the children be our guides as much as possible, and we often start our day outside. ❧

Your Unique Place

LOCAL PROBLEMS, LOCAL SOLUTIONS When a group focuses on one place at a particular moment in time, that place becomes unique. In each of these stories, slowing down and quietly observing the outdoor environment, children and teachers together discover unique resources to address problems in their community.

SHARING TRADITIONS The shíshálh Nation is reclaiming its culture, history, and language by focusing on the youngest community members in their traditional landscape. Teachers and the shíshálh community guide explorations and elders share memories from childhood and pass down ancient wisdom about local plants, animals, land, and water.

COMMUNITY RESOURCES In Giles County, Virginia, community organizations and volunteers offer lunch and studio art activities centered around the natural bounties of the Appalachian environment. The mixed ages of the participants alleviated insecurities and generated loyalty in the group. Allowing time for exploration and research led to the creation of an unusual community resource.

DISASTER RESPONSE In Miami, after a destructive hurricane, L'Atelier preschool brought its community together in solidarity. Storm debris took on a new life and spurred creative expression. Facing problems of climate change, the school arrived at an inventive solution.

A TEACHER'S PASSION A Rhode Island teacher shares her sheep's wool and her passion for the fiber arts. She engages the school community in collecting local plants to create dye baths and a new color aesthetic.

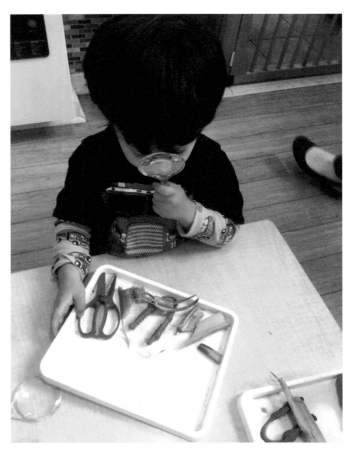

Examining cross sections of vegetables can open new worlds hidden in tiny spaces.

Her efforts encourage the community to come together to share fiber art traditions from various cultures.

ANDY GOLDSWORTHY Teachers at The Bishop Strachan School in Toronto, like many teachers in this book, reference the work of artist and photographer Andy Goldsworthy as inspiration for their escape to nature. Goldsworthy works directly with the land to create outdoor sculpture and designs by rearranging the natural materials he finds there. We believe he works in much the same way that children explore when allowed time and space outside on their own. His books and videos showing his process and creations are inspirational for children and adults alike.

Outdoor Explorations

Join with the Earth and each other to bring new life to the land, to restore the waters, to refresh the air, to renew the forests… to renew our spirits, to reinvigorate our bodies, to recreate the human community, to promote justice and peace.

Martin Luther King, Jr.

Outside and Just Beyond the Classroom Door

Developing a Sense of Place

PINNACLE PRESBYTERIAN PRESCHOOL
SCOTTSDALE, ARIZONA

Mary Ann Biermeier, Director of Professional Development
Sabrina Ball, Director

Heralded as one of the greenest deserts on the planet, the Sonoran Desert of central Arizona is home to numerous animal species, including the roadrunner, coyote, javelina, bobcat, and desert tortoise. In the springtime, the desert wears carpets of orange poppies and blue lupine. The mesquites and palo

Cacti have unique shapes and postures.

In springtime, the desert treats us to an explosion of flowers.

verdes offer an explosion of yellow flowers. Our senses awaken to this shock of color, light, and sound. This is the place the birds of North America make their winter home. This is the place we call home.

Desert Tortoise

Through her writings, educator and author Ann Pelo encourages us to reconnect our classrooms to the natural world. With her work in mind, in the fall, Pinnacle Presbyterian Preschool introduced a desert tortoise to our campus. Houdini, a rescue from a local animal shelter, found a new home on our playground.

The preschoolers meet Houdini in small groups to foster personal connections.

They observe the movement of this interesting desert creature and draw what they notice.

As the children observe Houdini, they pose questions about how the tortoise survives in the desert, fueling scientific and environmental inquiry. Nonfiction books and stories add to our collective knowledge. By recording the children's comments, images, and drawings, we teachers can see that they are working toward understanding this creature that has captured their imagination.

The children's drawings show us that they notice the patterns on Houdini's shell, as well as how Houdini moves. Drawing by Savannah.

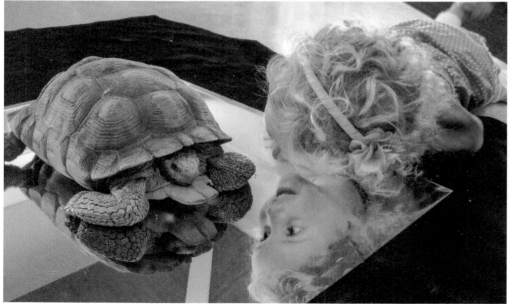

With the help of a mirror, the children are able to see the tortoise from all angles. "I wonder what it looks like inside her shell." –Scarlett

"I made an arrow because her head goes in and out. I made the arrow on the bottom because she moves forward very slowly." –Dax

Exploring Beyond the Playground

Our natural environment in the Sonoran Desert is not typically viewed as hospitable for young children. For years as a teaching community, we failed to see the opportunities just beyond the playground gate. After studying the lessons of Reggio Emilia schools, we opened our teaching practices to new possibilities.

Through the playground gate, just a few steps down the sidewalk, we find the cut of a sandy wash. The Spaniards named these ribbons of water *arroyos*. The packed sand provides solid footing and wide-open space for the children to explore. It is here that they collect many of the materials they will use in the classroom. It is here, beyond the playground, that they begin to get a sense of this special place that is their home.

"Why did the cactus fall down?"

A fallen saguaro cactus causes the children to pause and speculate.

> Sean: *I know about things. I think this cactus got struck by lightning.*
>
> Christina: *I think there were some owls in there, and they felt like it was going to fall.*
>
> David: *I liked the cactus. When the cactus fell over, I think it grew too tall.*
>
> Avery: *Maybe it got too much water.*
>
> Sean: *Lots of cacti get really tall and they don't fall down.*
>
> David: *It got too tall.*

As the children wander and explore, we discuss the names of the plants and creatures they encounter. They take pictures, draw, and create stories about their adventures. Classroom investigations and project work are driven by these experiences.

The preschoolers collect flowers, rocks, twigs, and the occasional snakeskin as they make their way down the dry arroyo.

Natural Researchers

Children are natural researchers. They want to touch and see. They seem to be on a mission to understand "Why?" and "How come?"

As educators, we have learned to step back, allowing children to investigate in their own unique ways. Carlina Rinaldi, president of Reggio Children and professor of pedagogy at the University of Modena and Reggio Emilia, defines this kind of research as "an attitude and an approach in everyday living, in schools, and in life, as a way of thinking for ourselves and thinking with others, a way of relating with others, with the world around us, and with life."

After visiting schools in Reggio Emilia, Italy, we were inspired to utilize more technology in our investigations of the natural world. We recently added digital microscopes to our atelier and classrooms. The children collect their own specimens and navigate the scope with confidence. Together, we marvel at the textures, designs, and colors that are hidden from the naked eye. Surprisingly, technology helps the children slow down and see nature on a deeper level, where there are never-ending discoveries to be made.

Cate explores a rib from a cholla cactus.

Inspecting a flower up close with a digital microscope.

Petal People

The room is filled with sweet scents as the preschoolers explore flowers. It is amazing how many tiny parts there are in a single bloom. As the children take apart the flowers, they learn the names of the parts and the role they play. We are left with lots of tiny pieces with which to construct.

When collaging with flowers and stems, the children create colorful landscapes, people, magical creatures, and dramatic scenes. Many of their stories reflect their own family and experiences. By leaving glue out of this activity, we give the children the opportunity to create again and again. Once a composition is finished, we take a photograph.

Taking apart the flowers is a science lesson. Reconstructing them as petal people is an exercise in imagination.

A Transformation in Practice

We have found that outside is where we do our best work, learn the most about the children, and discover new and intriguing projects. The materials that the children pick up are interesting and unique—much like the children themselves. Gone are the typical plastic items that once stocked our shelves. Now our desert home is always present in our classroom through the natural materials we collect and our school mascot, Houdini. We keep these traces of the desert always within reach of creative hands. 〰

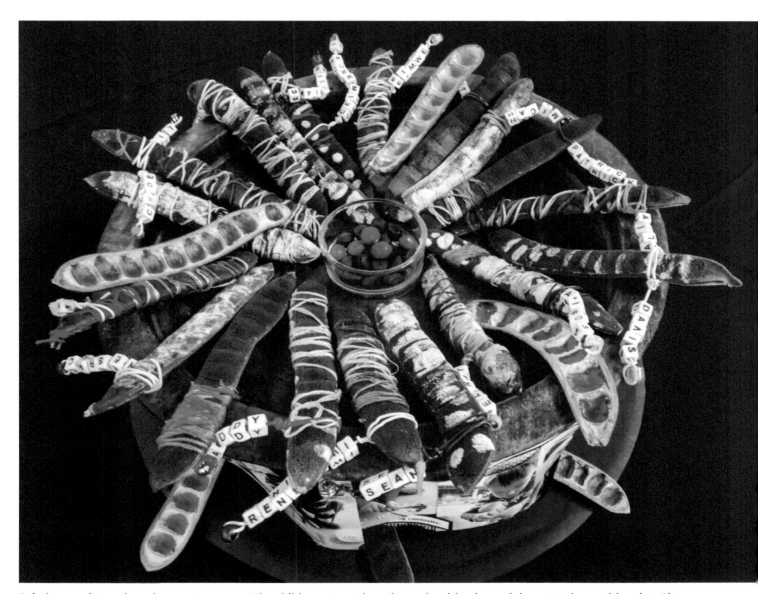

Dried mesquite pods make great maracas. The children strengthen the pods with wire and decorate them with paint. They are a favorite addition to group singing.

Fostering a Lifelong Love of Rivers

Our Third-Grade Connecticut River Valley Curriculum

CAMPUS SCHOOL OF SMITH COLLEGE
NORTHAMPTON, MASSACHUSETTS

Marie Frank, Third-Grade Teacher

At Campus School of Smith College, educational curriculum is considered a living organism, always developing and changing. One year, the faculty decided to take a fresh look at our science curriculum to see how we could create more experiential learning, substance, and depth from kindergarten to sixth grade. In the course of our discussions, I mentioned my lifelong love of rivers instilled by the Housatonic River that flows near the home where I grew up. Why not build a set of multidimensional experiences based on our own Connecticut River? From there our ideas really started to flow.

The Connecticut River Valley is rich with possibilities for firsthand experiences involving science and social studies. To learn about geology, we create mini rivers to see how channels are formed and how shallow or steep inclines create features such as meanders and deltas. In our studio art class, third-graders build clay relief maps of the Connecticut River Valley to highlight the topography of the land. Archaeology comes into play as we learn about the culture and lifeways of the Connecticut River Valley Native Americans.

Ecosystems in the Classroom

Raising an animal is an incredibly intimate experience. Our school participates in the national Trout in the Classroom program, which helps children develop an

Their detailed drawings show the scientific knowledge the students have gained by raising trout. By Moses, Jyotica, and Max.

Each boat is unique, and the students enjoy sharing stories of how they developed their design.

understanding of healthy rivers and a personal connection to environmental stewardship. The students raise trout from eggs, caring for them through the winter months and monitoring the water quality of their tank. In this way, they learn what the trout need to survive and thrive. They study the fish closely, including magnified images of the eggs at various stages of development. They draw their observations and write extensively about what they notice, what surprises them, and what questions they have.

Boat Building

At the end of the year, the third-graders construct boats out of natural materials. The guidelines for this project are simple: There is a size limit, and they have to be seaworthy and sturdy enough to withstand speedy currents. Fruit shells, leaves, sticks, vines, twigs, and bark are some of the natural building

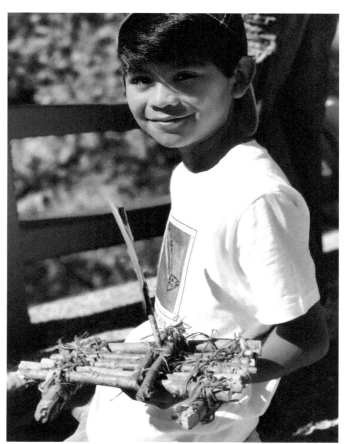

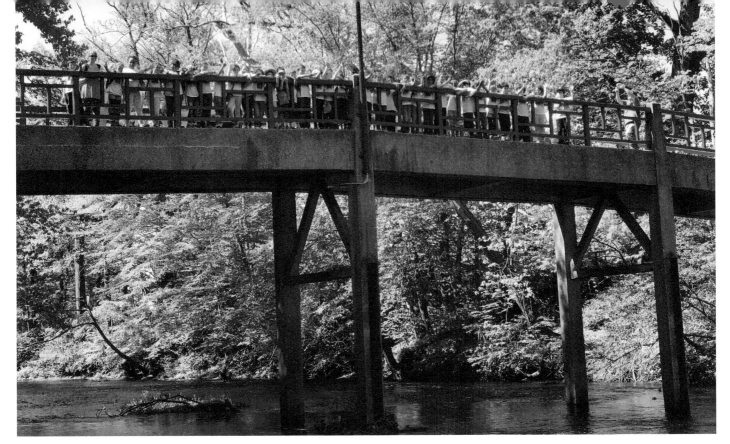

Third-grade classes gather on the bridge for the boat launch.

materials the students suggest during our brainstorming session. They discover even more materials as they create their boats at home with family support.

When the students bring in their finished boats, my third-grade level partner, Jan Szymaszek, and I are amazed at the ingenuity, variety, aesthetics, and crafty problem-solving of each vessel. To save a memory, many of the third-graders draw their boats.

Riverfest

The culmination of this yearlong experience is the Grade Three Riverfest. This celebration includes guest speakers, singing, and a buffet lunch on the banks of Mill River, which is within walking distance of our school. The children wear T-shirts specially made for the event, featuring their trout drawings.

A parent, an inventor himself, built a launcher to lower the boats into to the rushing water from the bridge. Each student makes a wish, and we cheer as the boats are swept downriver. It is a beautiful and empowering moment.

We also release the trout that the children hatched and cared for during the winter months. These fish, introduced into our local stream, remind the students of the fragile balance of our waterways and help them feel a sense of involvement in their stewardship.

Riverfest solidifies the memories of all the Connecticut River Valley experiences throughout the year. The river is the theme that runs through everything we do. ॐ

Boats are lowered down to the rushing water on a launcher built by a parent.

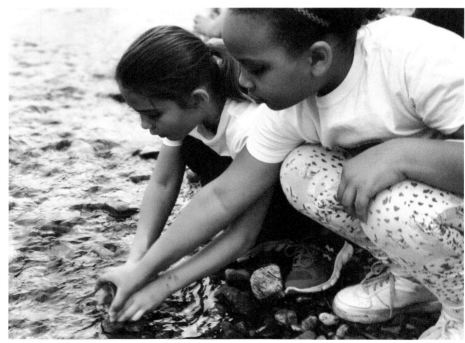

The children carefully release the trout hatchlings they raised in the classroom. They understand that their efforts have improved the local ecosystem.

Five Thousand Two Hundred Ninety-Two Acorns

Designing Efficient Counting Strategies

SABOT AT STONY POINT
RICHMOND, VIRGINIA

Mauren Campbell, Third-Grade Teacher-Researcher
Andrea Pierotti, Third-Grade Teacher-Researcher

Each year, new third-graders arrive at Sabot at Stony Point, ready to develop their number sense and practice place value—ones, tens, hundreds, and thousands. Over the years, we have found that proposing a class collection of 1,000 small objects is a great way to engage the children's interest. By seeing, touching, and manipulating many small objects, the concept of place value coalesces in a way not possible using pencil and paper alone.

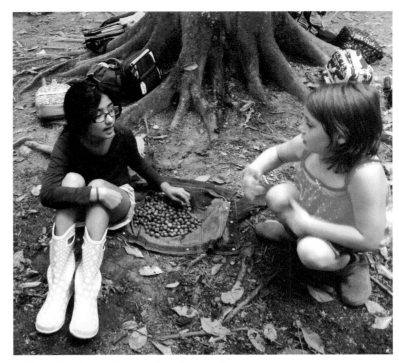

Bella and Kaiya notice an abundance of acorns on the playground.

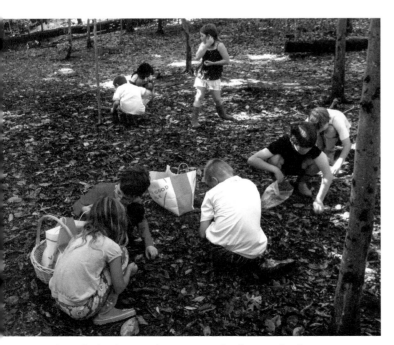

The whole class gathers acorns in the nearby forest.

This year, when we proposed the idea, the children struggled to decide *what* to collect. Past classes counted 1,000 pennies, bottle caps, Halloween candy wrappers, and the like. It happened to be an unprecedented year for acorns in Virginia—we kicked them around almost everywhere we went. Acorns covered the paths and often caused us to roll our ankles or trip as we played. At recess one day, Bella and Kaiya began gathering acorns, filling their lunch boxes and jackets. They counted as they went, often pausing to discuss how many more they would need to reach 1,000.

Back in the classroom, the girls' excitement about the acorns caught the attention of their peers. When the children saw how many the girls had collected in just an hour, the whole class itched to get started. The next day, we made a special trip to the forest, and the students spread out and gathered as many acorns as they could, filling plastic bags, buckets, and baskets.

Without an organized method of arranging, the children struggle to keep track of their count.

When we returned to school, the children spread out on the blacktop and began to count. They quickly realized that keeping track of such large numbers would be a challenge.

The third-graders had spent time counting smaller quantities of found objects, discovering efficient strategies along the way. To remind them of what they had learned, we asked, "How can you organize the acorns so that if someone wanted to know how many were in your pile they wouldn't have to count by ones?"

Once the third-graders grouped the acorns into piles of ten, they quickly realized the advantage of counting by tens instead of ones, then hundreds versus tens. They could "skip" all the numbers in between because they had already done the hard work of organizing into groups. They found that the same skip-counting could be used to create grids of 1,000 acorns. It also made it easier to double-check their friends' collections.

Deciding on an Organizing System

As groups created separate arrays of 1,000 acorns, the class realized they had far surpassed their goal. Until this point, the children had worked in teams, each team counting only a fraction of the class's collection. They now wondered how many acorns they had collected in total. Without fanfare, the children decided on one organizing system. This was a collective, tacit agreement.

The children worked until all of the acorns were arranged in grids. After the hard work of organizing, the counting was easy. The third-graders skipped along

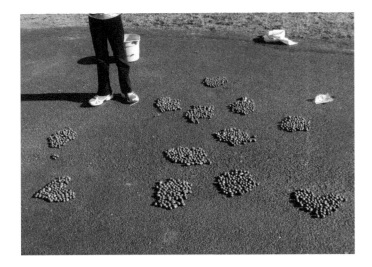

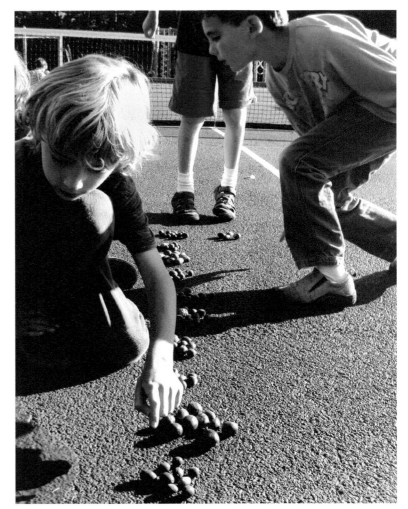

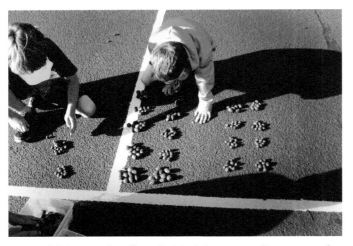

Some children make piles of 100. Others compile groups of 10, then organize those into grids of 100.

Organization and Aesthetics

beside the squares counting, "1,000 ... 2,000 ... 3,000 ... 4,000 ... 5,000." Because they had touched and manipulated the piles of ten and seen them grow into rows of 100 and then squares of 1,000, they understood *how* we were able to count by thousands.

After the five squares of 1,000, they counted the leftovers: two more rows of 100, nine piles of ten, and two lone acorns. After rechecking, everyone agreed. They had 5,292 acorns.

When children counted collections in the past, we teachers had found ourselves trying to rush them along. We wondered, *Why are they organizing the objects by color? Can't they just hurry up and count them?* This time we watched more closely. We came to understand that designing an organized arrangement is a first step in the challenge of counting objects. It's easier to distinguish the groupings when they are arranged by a unifying property. That experience informed this one and many that followed.

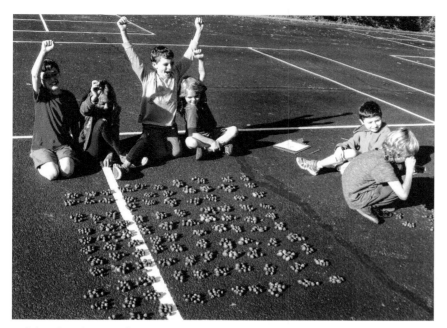

Celebrating the creation of an array of 1,000 acorns.

The acorn boom took our counting experience to new heights. By using natural materials from our local environment, we collected many more objects than we had in the past. Because the number of objects was so large, organizing was even more critical. The groups that spent time organizing their acorns had the easiest time double-checking their final count. The organization devised by the children made counting such a large sum easier and more accurate, and it gave them a great sense of accomplishment. Clearly, organizing is a way of clarifying understanding and making meaning. At the same time, organizing is both a mathematical and aesthetic process. Beautiful design is not just nice to look at; it aids in our understanding. ❧

The class devised a system for displaying and easily tallying the acorns.

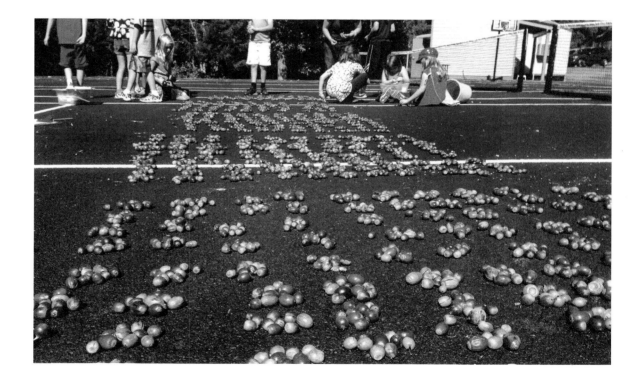

The Tube Story

A Collaborative Effort on the Playground

TOUCHSTONE COMMUNITY SCHOOL
GRAFTON, MASSACHUSETTS

Nancy Baffa, Early Childhood Teacher

Touchstone Community School, an independent school for pre-K to eighth grade, is nestled in the rolling hills of Grafton, Massachusetts. We are committed to spending time outdoors—gardening, hiking, exploring, and playing. Our property has wide-open spaces, varying terrain, and a wooded area that inspires imaginative and constructive play.

In addition to spending time learning outdoors, our students have all-school recess each day, fostering multiage interactions and play. We have a garden educator who works with the children to grow fruit, vegetables, and herbs, which we use for snacks and cooking projects. In fact, one of the expectations we have of our eighth-grade graduates is that they know how to grow their own food.

Opening the woods for free play during all-school recess has led to the creation of intricate forts and natural art projects.

Wandering off the Path

In years past at Touchstone, we walked the "nature trail" on our school grounds, but students weren't encouraged to wander off the path. Two years ago, we opened the woods and the small creek that runs through it for play during recess. This has led to nature exploration and a greater awareness of the animals that share our property. A parent installed motion-activated cameras so we can see the animals that are here when we are not.

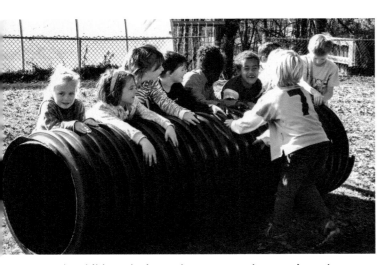

1. The children devise a plan to move the massive tube. Some direct, others steer, and everyone pushes.

2. They work collaboratively for nearly fifteen minutes, rolling the tube around a fence, across a field, and up the hill.

Over time, we have become more comfortable with allowing the children to engage with their environment. We thoughtfully consider the risks versus rewards of outdoor activities. For example, when children want to hang on a tree branch, we test it to ensure it is sturdy. On our regular excursions into the woods, we bring trowels, magnifying glasses, flashlights, writing tools, and clipboards with drawing paper. These tools allow the children to look more closely and notice details. Understanding that our use of natural spaces has an environmental impact, we teach the children to be stewards of the environment.

Later, Liam wrote about the experience, and the children reenacted it, to the delight of their sixth-grade partners.

The Tube Story

The Tube Story occurred when just the early childhood class was on the playground. Liam wondered if the giant plastic tube on the lower playground would roll, but dismissed the idea, realizing that he couldn't move it to the top of the hill to test it out. Ginger, overhearing Liam's idea, moved about the playground telling others, rapidly building excitement about the possibility of moving the tube.

What is extraordinary about this story is that the whole class got involved in the activity. Without the help of adults, the children devised a plan, took on different roles, and supported each other, leading to success in achieving their objective of moving the tube.

Spending more time outside, implementing whole-school recesses, allowing children to take risks and engage with natural spaces, and keeping a camera handy has allowed us to see that free play on the playground can lead to extraordinary happenings. ❧

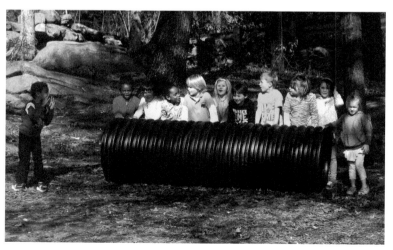

3. With the tube finally in place, Neway leads the countdown to release it.

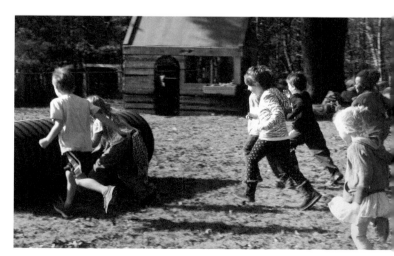

4. All their hard work pays off as they gleefully chase the runaway tube down the hill.

Winter Transformations

THE BISHOP STRACHAN SCHOOL
TORONTO, ONTARIO, CANADA

Amanda Humphreys, Lead Teacher
Anna Papageorgiou, Kindergarten Teacher
Kerri Embrey, Grade One and Lead Teacher

One day during recess at The Bishop Strachan School, there was a collective gasp and squeal of glee when the first snowflakes suddenly started to fall. Even the students who have seen snow each year still celebrate its arrival. Snow is awe-inspiring in the delicacy of its descent, the flakes' intricate designs, the way it collects, and how it can be shaped and transformed.

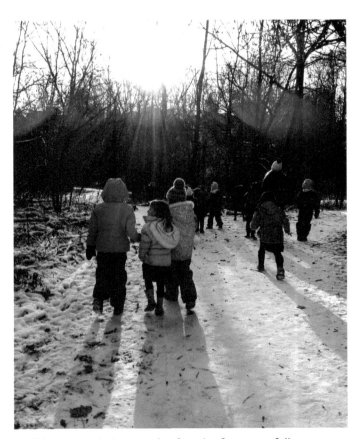

Walking through the woods after the first snowfall.

"The Snowmaker makes the patterns on the snowflakes, and when it's really cold he throws them out." –Nya

We overhear the senior kindergartners' and first-graders' imaginative exchanges about how snow is made, how it falls, and snowflake design:

> Snow comes from the clouds. It's little pieces of them. It is kind of icy water because they [snowflakes] melt easily. They are not as cold and hard as ice, but softer and warmer. When you lie down, you see pictures in the sky … in the clouds.

> A snowflake wouldn't be a snowflake if it wasn't organized.

> A structure in a snowflake can change. It grows and grows; it falls down flat in your hand, and it melts into a drop of water.

Drawing Their Theories

Picking up on the children's enthusiasm and interest, we ask them to draw their understanding of where snow comes from. Drawing their theories as we record what they say helps them develop their ideas. It also shows us the intentions behind their choices of detail and form in their drawings.

Predicting and Experimenting

While playing outside, we hear the children wondering what would happen if water were mixed with natural materials and left outside. They make predictions:

It will get cold, and it will grow.

It will change color when we put it outside.

If we put a little snow in it and then put water in it, it will make different colors and then turn white.

The one with the snow in it will melt first and come back into water and then into ice.

We conduct the experiment using pine cones, needles, pebbles, and tree seeds. The students go outside every few moments to check on their creations. They are fascinated when transformation begins, only realizing later that it is ice. They can see bubbles, and when they pick the sculptures up, they are surprised to find that

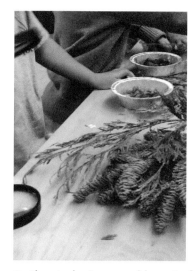

As the students assemble materials, they wonder if the cooling water will alter what is put in it. They also theorize that the ice will hold its shape.

the inside is still liquid while the top layer has become solid, fixing the natural materials in place. They are sure their sculptures will fall apart when they take them out of the containers. It feels like magic when they hold their shape.

In the days that follow, we experience unseasonably warm weather. The children are surprised and disappointed when their sculptures are gone, leaving just the strings hanging from the trees. They find the natural materials on the ground and are puzzled that they were left behind when the rest of the sculpture disappeared. We remind them of their predictions and theories, and they reflect on how they observed the water go through stages as it turned to ice and back again.

Here at The Bishop Strachan School, we are fortunate to have dramatic seasons. Winter provides us with many natural phenomena to explore. We feel that working outside with natural materials is an important way of knowing about the world. Children connect and reconnect so quickly to nature and to the materials in our environment. More and more, we use the environment as a third teacher, complementing both our inside and outside spaces. ❧

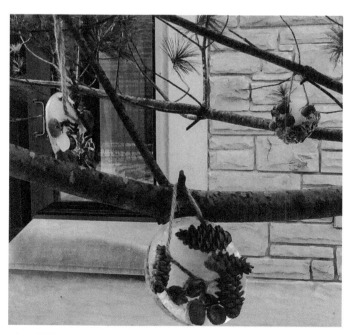

The children remove the ice sculptures from their tins and hang them on branches to catch the sunlight.

Outdoor Explorations

ORGANIZING Organizing as a prelude to getting things done is told in two stories. Third-graders at Sabot at Stony Point in Virginia figured out how to organize their enormous collection of acorns for easy counting. Their teacher reflects, "The thing that struck me the most has been the idea that aesthetics—the beauty and organization of the design they evolved—could have actually aided the children in clearly expressing a mathematical concept."

The pre-K and kindergarten children at the Touchstone School in Massachusetts organized themselves, as opposed to objects, to accomplish a task that would be physically impossible alone. And they did it without the help of a teacher.

SAFETY AND RISK-TAKING Several teachers addressed safety and risk-taking, which is always a delicate balance. At the Pinnacle School in Arizona, teachers found a safe way to go beyond where the school grounds end and the desert begins in order to explore the creatures and vegetation that thrive there. At Touchstone School, wandering off the path and into the woods opened up new investigations. The teachers were aware of risks but found ways to be prepared and watchful.

DRAWING THEORIES We were struck by the inventive ways that children drew their theories and observations. At the Bishop Strachan School in Toronto, Nya's drawing illustrated her understanding of snow. At Pinnacle Presbyterian Preschool, Savannah and Dax drew the movements of the desert tortoise, and the markings and patterns they observed on its shell. A drawing can serve as both documentation and self-reflection.

Creating an organized—and beautiful—arrangement makes counting easier.

CULTIVATING EMPATHY As children take responsibility for raising trout and caring for woodlands, they draw closer to the natural world, gradually becoming stewards of the land and waterways. The teacher at Campus School of Smith College in Massachusetts pointed out the empathy with which her students released their hatchlings into the wild, much like parents full of hope for their children as they send them off to school.

SPONTANEITY Being open to surprises from nature can be difficult for busy teachers. At the Bishop Strachan School, teachers changed their plans to allow their students to enjoy the first snowfall of the year. When they let the children and nature take the lead, explorations yielded many unexpected discoveries. In each of these stories a strong sense of community grew as children explored nature outside of the classroom.

Bringing Nature Inside

> *Holding things is understanding form. Touching things, making things helps you understand shapes and form. You need to use your hands as well as your eyes.*
>
> Henry Moore

Close Study of Life Cycles

Scientific Observation and
Beginning Writing

CAMPUS SCHOOL OF SMITH COLLEGE
NORTHAMPTON, MASSACHUSETTS

Janice Henderson, Kindergarten Teacher
Penny Block, Kindergarten Teacher

From the very beginning of the year, we want our kindergartners to be interacting with nature. For that reason, at Campus School of Smith College we start our science curriculum with natural things from our local environment that we can bring into the classroom for close study. We have insects and plants for the children to explore with their senses.

Modeling a caterpillar out of clay trains children to be close observers. Representing something so complex helps them realize early on their power as creators.

"I noticed it has little white dots on its feet."
–Calliope

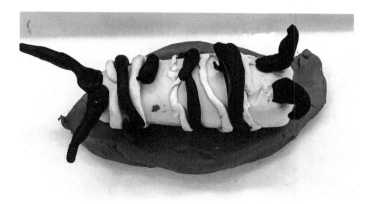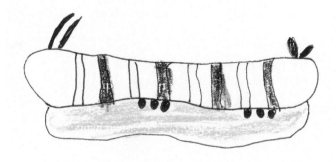

Constructing in three dimensions from direct observation first makes the more symbolic representation of drawing easier.

Starting with Caterpillars

Monarch caterpillars greet the new students as the school year begins. They get right up close with them, even allowing them to crawl on their hands. They observe the feet and antennae of the caterpillar. Learning and using the names of the parts, noticing the properties of the caterpillars—textures, shapes, and colors—leads to constructing their own caterpillar out of modeling clay.

We have found this sequence—close observation of nature followed by discussion and visual representation—to be a strong foundation for growth and success for the rest of the year in kindergarten. The children also witness the development of the chrysalis and the emergence of the butterfly. They represent these exciting stages in the life cycle of the monarch in many ways, creating books, murals, and more. Releasing the butterflies to begin the cycle again prompts much celebration as well as concern for this imperiled species.

We love to step back and marvel at all the details the children notice and recreate, as well as how each caterpillar sculpture is unique. After modeling the caterpillars in clay, the children also draw them. In these ways they learn about scientific representation.

Drawing from Observation

Early in the year, our art specialist works with the children on drawing strategies. The kindergartners learn to plan and practice first with a capped black fine line marker. Drawing with a fine line marker allows them to include tiny details and textures. The children practice crayon skills—using the tip for small details, the side to fill in larger areas—before adding color to their drawings. This sequence of drawing first with a fine line pen then adding color helps them confidently represent their observations and understandings. We use these techniques all year long in all curriculum areas.

At first, the teacher records the class observations.

Name _____

Date February 2 6 2016

This is what I saw in the tank today.

We noticed

the pumpkin is starting to decompose. It has BIG white spots on it. There are brownish black and bluish green spots too. It is watery. It is beginning to smell. The peduncle is black. On one side of the pumpkin the skin is still orange and round and the other side is decaying.

Studying Pumpkins

As fall approaches, we visit a pumpkin patch, and each kindergartner picks one. Back in the classroom, the children weigh their pumpkins. They study them in the same way they studied the caterpillars—noticing the parts and properties and then recreating those details by sculpting clay and drawing from observation. We buy a giant pumpkin for the classroom, and the children use a balance scale made from a plank and fulcrum to find out if they weigh more, less, or the same as the pumpkin. In December, we put a pumpkin on soil in a glass tank and cover it with plastic wrap. Each time one of the children notices that the pumpkin is changing, we gather as a group to share, record, and draw our observations. We repeat this process about once a month. In the spring, green shoots start to emerge from the decomposing pumpkin.

Writing about Bulbs

When the days are short and the weather cold in New England, we bring narcissus bulbs (paperwhites) into the classroom to observe. One of the parents, a horticulturist, introduces the paperwhite bulb as "a different kind of packaging for a seed—like a lunch box with everything inside that is needed for it to grow into a healthy plant. All it needs from us is water, light, and warmth." We gather in groups to share and discuss our observations before the children draw their bulb. We stress that this is a special kind of drawing—a scientific drawing—that tells others exactly what you are seeing. The kindergartners are familiar with this expectation by now. They know the difference between imaginative and scientific drawing. For these kinds of experiences, we really play up the scientific part. With support, the kindergartners also write down their observations. They sound out the words, often inventing the spelling.

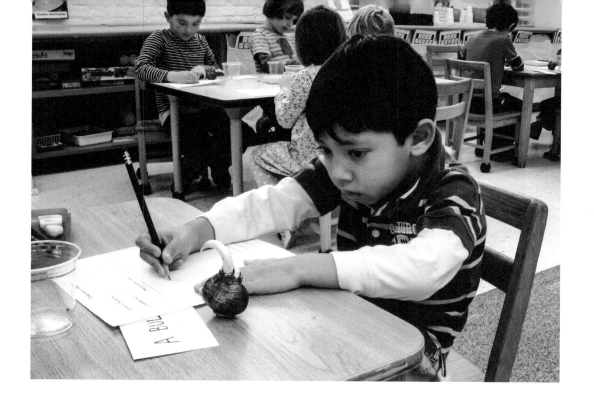

The paperwhites grow so quickly that the children observe, write about, and draw significant changes each week. Then the blossoming bulbs go home with them for the winter break.

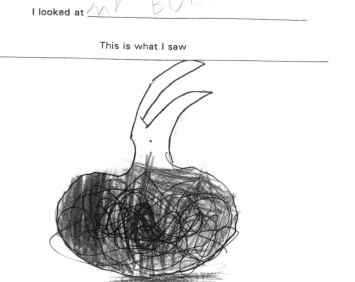

Name of Scientist ELI

I looked at MY BULB

This is what I saw

I noticed AT HE A RLLE TL SPROT

"It has a really tall sprout." –Elias

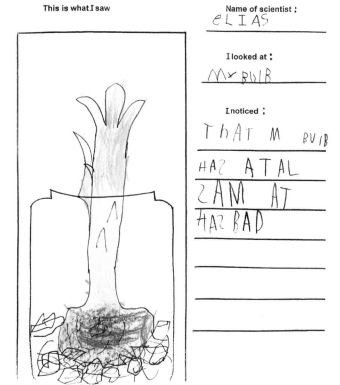

This is what I saw

Name of scientist :
ELIAS

I looked at :
MY BULB

I noticed :
THAT M BULB
HAS ATAL
SAM AT
HAS BAD

"My bulb has a tall stem at his back." –Elias

101

Sprouts for Our Gardens

In the spring, the children explore, draw, and write about scarlet runner beans as a prelude to studying its life cycle. Once the beans have grown into leafy vines, the children take them home to plant with their families. They often send us pictures and notes about the beans' progress over the summer. In the school garden, we plant beans from the previous year's harvest and the pumpkin vines that have by now overgrown the tanks in our classroom. The garden becomes a gift to next year's kindergartners and begins the observation of life cycles all over again.

Our life cycle study is constantly evolving. We marvel at the children's excitement, curiosity, knowledge, and the skills they develop. After studying life cycles, they notice other cycles too, like the days of the week and the seasons. At the same time, we have intentionally incorporated STEM curricular areas—science, technology, engineering, and math—as well as literacy work in reading and writing, into our life cycle studies. All this just whets the children's appetite for more study and close observation of the natural world. ❧

The children sprout and tend to the scarlet runner beans until they are ready to plant.

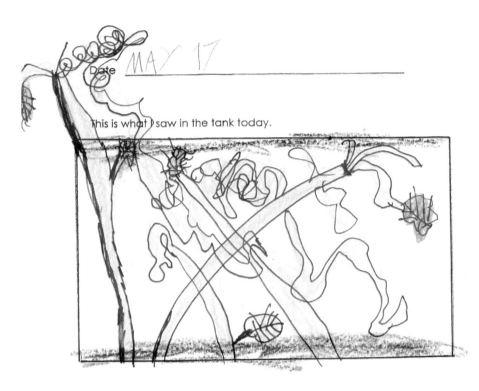

Date MAY 17

This is what I saw in the tank today.

"It is growing out of the tank. It looks like a pumpkin plant jungle. The leaves have changed shape and color. The leaves have a point and they are really big now. It is the life cycle!"

Anna uses an array of crayons that match the organic colors in the leaves, vines, and soil.

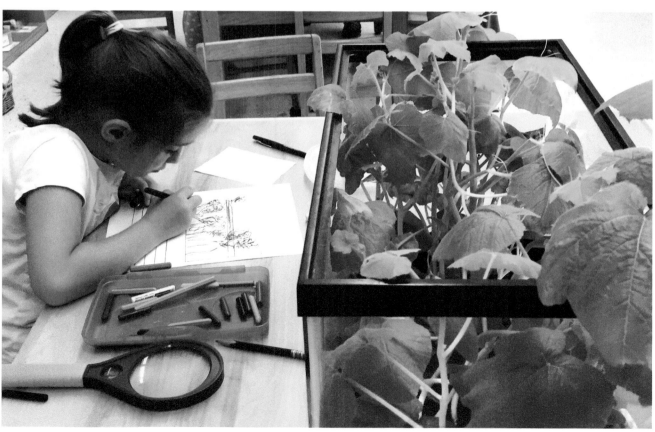

A Community Comes Together to Make Tomato Sauce

ACORN SCHOOL
TORONTO, ONTARIO, CANADA

Rosalba Bortolotti, Director

When I founded this early childhood center over seventeen years ago, planting a garden and involving the whole community in harvesting, cooking, and sharing a meal was my first community-building event. The idea of giving gardening and cooking a central place in the school was inspired by

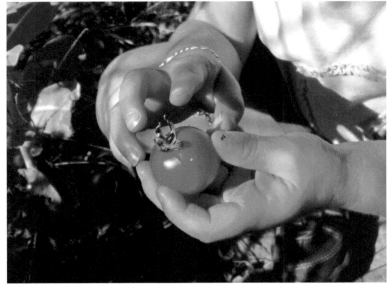

Children identify and pick ripe tomatoes, basil, and parsley.

visits to the early childhood schools in Reggio Emilia, Italy, and by my Italian parents and grandparents. A highlight of my childhood, and perhaps my strongest memory, is making tomato sauce every fall. My entire family—parents, grandparents, and cousins—set aside a whole day for this activity. We began at 6:30 a.m. and worked until the evening, when we shared the fruits of our labor.

I wanted to recreate that same feeling of belonging and well-being in my school community. I wanted to bring everyone—children, teachers, parents, grandparents, and siblings—together. Participating in preparing, cooking, and sharing good, healthy food seemed a perfect way to begin building community and relationships.

Every child takes a turn
sorting and washing tomatoes.
Tasting is also part of the process.

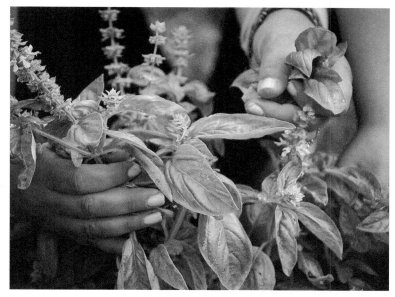

Every sense is awakened when working in our school garden.

Tomato Sauce from Beginning to End

Every child at Acorn School participates in the sauce making. It gives them a sense of pride to be part of such a large community effort. They first sort through the tomatoes to carefully pick out the rotten pieces and place the others in large tubs to wash.

We set up studio areas for taking breaks to marvel at the harvest collections. Drawing materials, paint, and a variety of other expressive media are available for free exploration. Everyone is encouraged to take time to look, identify, sort, smell, and taste our beautiful vegetables. Setting and decorating tables is also part of the preparations.

Cutting tomatoes requires attentiveness, skill, and practice. Adults and children work together with respect for the dangers and excitement of using sharp knives.

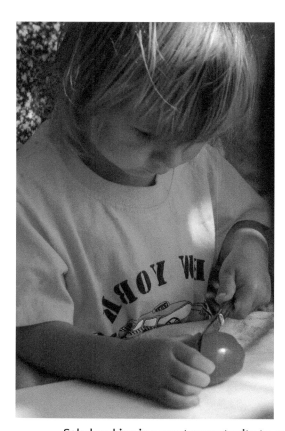

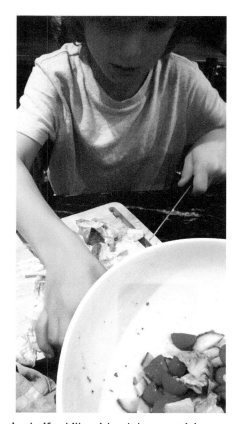

Salad making is a great opportunity to practice knife skills with adult supervision.

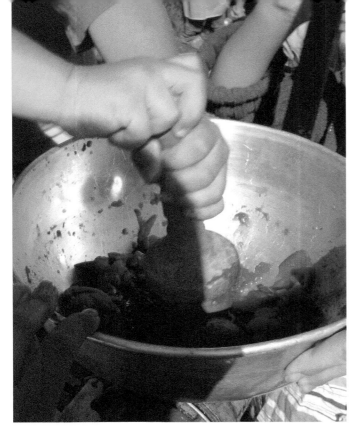

Children and adults work together to separate seeds and skin from the tomatoes. Grinding, scraping, pounding, and stirring are a few of the actions required.

Sharing Traditions

We use a "tomato-crushing machine" (so named by the children) that is a family heirloom. The design is derived from a tool my grandfather used in Italy. When he and my grandmother immigrated to Canada many years ago, they were not able to find the same tools to carry on the family canning traditions. Over the years, various tomato-grinding apparatus have been sold in stores, but my father, an engineer by trade, chose to make his own based on traditional tools. We have kept this one in our family and have taken care of it for many years. Using traditional tools and techniques and learning their history helps our community build relationships. It also encourages other families to share their foods and traditions.

Engaging children in the kitchen with food preparation has a strong meaning from a pedagogical and cultural perspective. Being in the kitchen is a sensory experience. The tomato project has become a way to welcome

Using the "tomato-crushing machine" designed and built by my father.

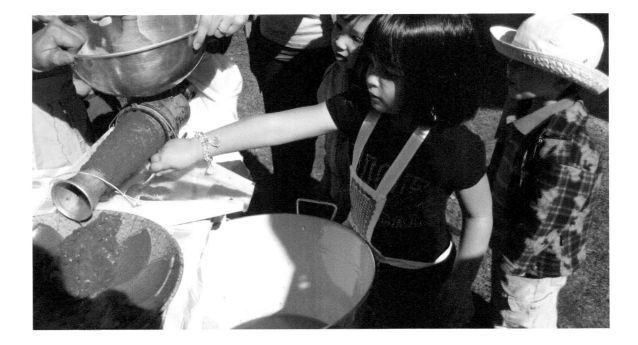

After working together all day, everyone sits down to enjoy a communal meal.

families into our school, and we build all year on the experiences of that day. Food ties into culture, values, emotions, a sense of belonging, and the development of relationships. Our gardens have become a community meeting place. Food is the catalyst for discussions about what to plant as well as sustainability, responsibility, and shared values. These dialogues encourage families

Each family gets a jar of sauce to take home.

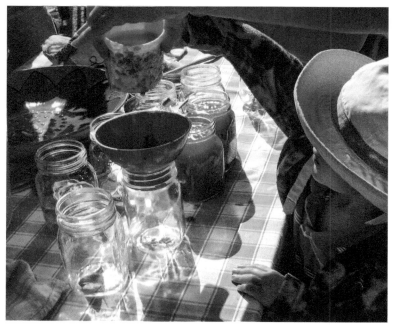

to share their traditional foods, spices, tools, and approaches to food preparation with the school community. We have found that the tomato project means as much emotionally to the families as it does to our school. One student's grandmother from India planned her annual trips to coincide with our community harvest and sauce making. It is our goal to find ways to involve more grandparents and other family members in this tradition, to learn new perspectives.

Every year our experience grows, deepens, and takes unexpected turns. Older children show younger children their favorite parts of the process. Memories of the kitchen, dialogues about food, and impressions from our "atelier of tastes" linger throughout the school year. Word has spread, and we have come to be known as "the people who make tomato sauce at the beginning of every year." Food connects everything! ❧

Gorgeous Brown!

CENTER FOR EARLY CHILDHOOD EDUCATION
SMITH COLLEGE
NORTHAMPTON, MASSACHUSETTS

Cathy Weisman Topal, Studio Art Teacher
Shauneen Kroll, Teacher of Three-Year-Olds
Rita Harris, Teacher of Four-Year-Olds

As a studio art teacher at the Center for Early Childhood Education at Smith College, I work closely with all the teachers. We share a strong belief that playing and exploring outside is the healthiest and most effective way for children to develop physically, emotionally, socially, and intellectually. Here are some of our favorite explorations with natural materials.

Finding Many Browns

Many years ago, when our city's population was a lot less diverse, Shauneen Kroll noticed one of the three-year-olds washing his hands a lot. "I don't want to get dirty like him," he said, referring to the only child with brown skin in the class. Shauneen shared this story with the other teachers, and we thought a lot about what we could do to help the children be more appreciative of differences.

The children had just been on a "green walk" around our center, looking for and collecting green leaves, twigs, and other materials. A brown walk seemed a natural extension. Collecting browns gave them a different lens for looking. When we laid out their collection of bark, dried leaves, grasses, and seedpods, they could see how many beautiful varieties of brown there were.

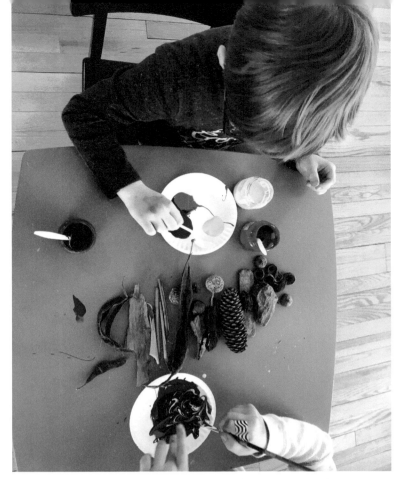

Take a spoonful of red, yellow, and blue paint. Mix, mix, mix! What color have you made?

A Color-Mixing Experiment

I prepared jars of red, yellow, and blue paint for color-mixing. I asked, "Why do you think these are called primary colors? What do you think will happen if you mix all the colors together?" To find the answers, I invited them to try an experiment:

1. Take one spoonful of each of the primary colors in a little container.
2. Mix until there are no streaks and you can see what color you have made.
3. Look at the brown materials we collected. Does your paint match any of them? If not, how could you make your mixture match one of the items?

Jiyan: *Ooh, this is turning black! Look, Adam. Oh, mine almost matches that, but mine is a little more blue.*

Emma: *Look, it's dark, dark. It's purple actually.*

Kristi to Braeden: *Your brown is reddish.*

Braeden to Kristi: *I know because I used a lot of red.*

Kristi: *This is gorgeous brown!*

Kevin: *It's turning green! Ali, look at mine.*

Ali: *Mine is purple, and his is more brown. Brown is for boys, and purple is for girls.*

Reiko: *My brown is different because I used a little more blue. You did the same thing as me! Did you put two globs of blue in? Now put some yellow in.*

Alexander: *Mine is greenish-brownish.*

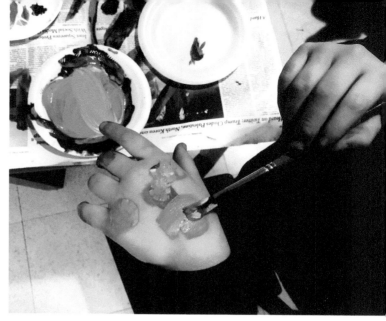

We offer white paint along with the three primary colors and challenge the children to mix a brown that matches their skin.

See if your mixture matches something in our brown collection.

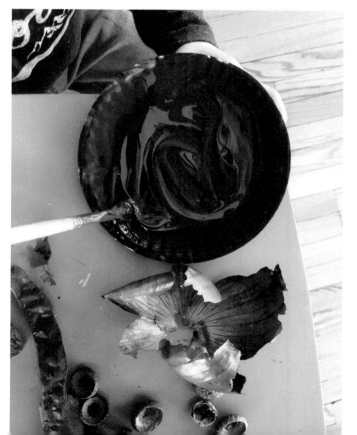

More Mixing

I invited the children to bring their paint cup back to the mixing table and this time add an additional spoonful of **only one** primary color. Before they mixed it in, I prompted them to make a prediction: "Think, "How will my spoonful of _____ change my mixture?" For instance, what do you think will happen if you add more yellow?"

Toula: *It is going to get lighter.*

Anais: *It's going to get so lighter. It will be a goldy-brown.*

Toula: *Definitely a goldy-brown.*

It was a happy accident when one child didn't add any red to his mixture, which prompted an exploration of green. The children tried other mixing experiments, including taking away one primary color and looking for more matches of secondary colors. Teachers, parents, and children brought in vegetables and fruit for more color mixing and matching fun.

109

Centerpieces

As winter approached, classes of all ages took another brown walk to collect dried plant stems and seedpods. Since the stems are fragile, cutting and gathering must be done carefully. Cutting stems is a great way to practice scissor skills. With all these new materials coming into the classroom, we decided to begin a new collection.

The older children cut dried grasses and flower stems with garden shears. By narrowing the focus to collecting dried plants, subtle differences between stems stand out.

Some branches were simply too large to bring into the school and needed to be broken down. The children helped cut, sort, and display the stems. Organizing the stems helped us identify plants and see each structure more clearly. A few children working with clay playfully stuck stems into their sculptures. Suddenly we realized that we could create centerpieces for our class Thanksgiving celebration.

I told the children to choose just three stems to begin. This encouraged them to slow down, look closely at the qualities of each stem, and make deliberate choices. Slowly turning arrangements allowed them to see where more could be added. Some stems were still too long and had to be clipped to fit.

Exploring outdoors in the fall, the children find many variations of brown.

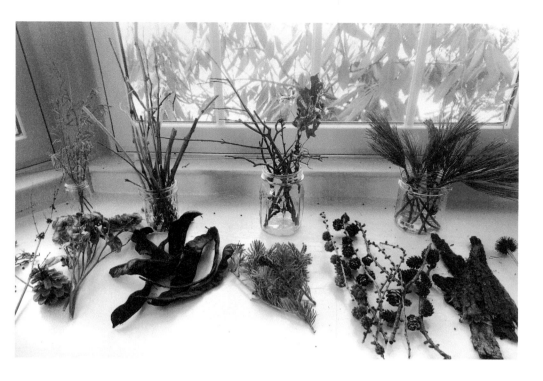

An organized display of stems is calming and feels approachable. It's easy to see what you have to choose from.

A ball of soft clay in a muffin cup makes a sturdy base for the stems.

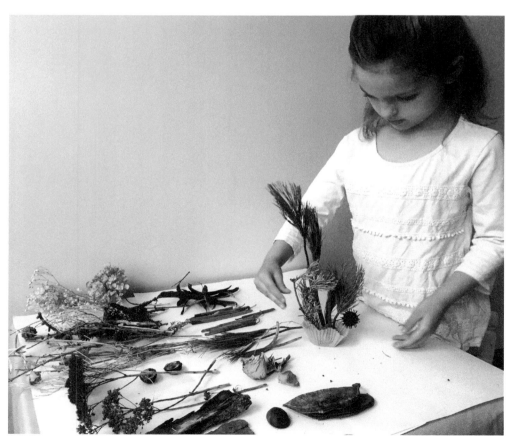

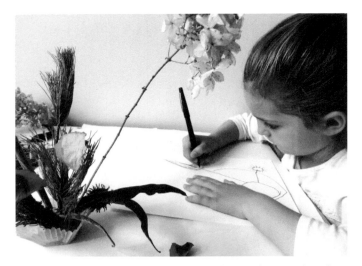

Drawing helps children appreciate their creations and notice differences in linear structure, shape, color, and texture.

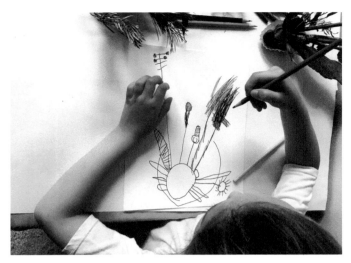

Clara uses colored pencils in autumnal colors to add highlights to her drawing.

Observational Drawing

As a way to really look at and appreciate the unusual centerpieces, I proposed drawing them. Studying the arrangements by turning them slowly opened up new points of view. I encouraged the children to start by observing the differences in the stems. Drawing each stem from the bottom up gave the young artists a place to begin.

Clara's mother captured her running commentary as she worked. Her words give us insight into her thinking. She is problem-solving, quantifying, making observations, associations, predictions, and similes.

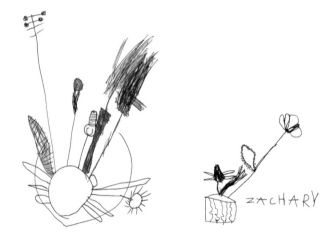

By Clara, age 4, and Zachary, age 6.
Creating centerpieces works well for all ages and is a great way to introduce and practice observational drawing.

That round thing looks like a sunflower.

I'm going to make some branches.

I think the pine branches are going to be the hardest.

I'm making it curved like a cup.

I'm doing a pine cone—stripe, stripe, stripe.

Another pea, another pea—there's three on each side.

That's too many flowers. I'll just do two.

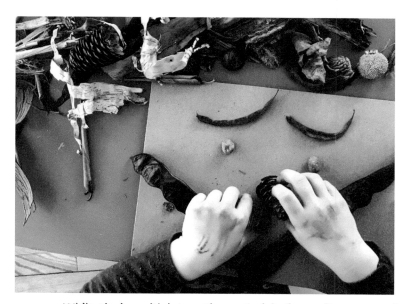
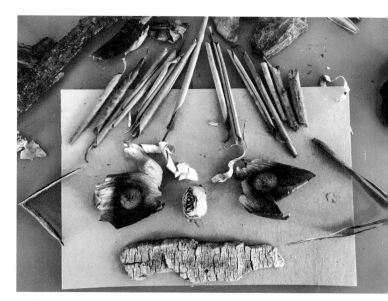

While playing with interesting materials, faces often appear. A piece of cardboard is helpful to define a work area.

Masks from the Forest Floor

Gorgeous brown materials were taking over the preschool. I had been trying to figure out a mask lesson for first-graders involved in a social studies/science unit on the forest. In many cultures, masks are created from materials found in the environment. I noticed a few children playing around, making faces from the natural materials we had collected. Creating masks from materials found on the floor of the forest would be a perfect extension. I gathered more natural materials as well as mask examples from different cultures and regions for my first-graders to discuss and study for ideas.

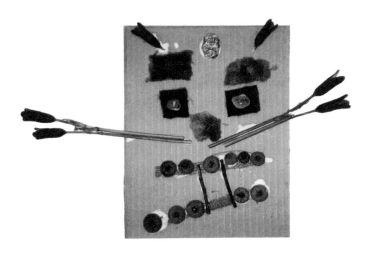

Natural materials leads to the creation of unusual faces of both animals and humans. Painting them adds another dimension.

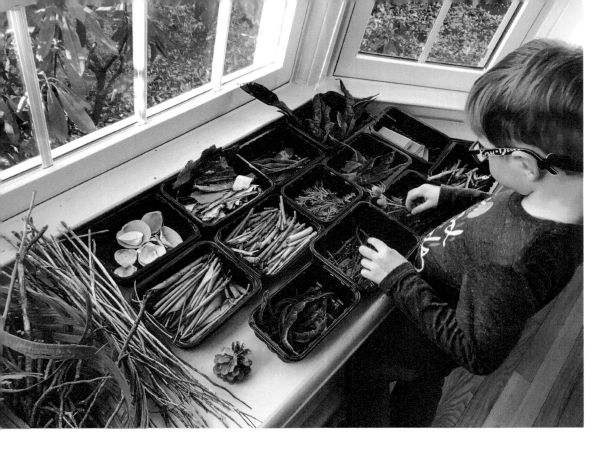

Displays of materials change as the need arises. Materials organized into containers are easy to set up, use, and move when necessary.

Shelters and Feeling Safe

Rita Harris, teacher of the four-year-olds, was watching her students try to construct with the collection of natural materials in her classroom. She proposed the idea of constructing shelters. Each child chose a little animal figurine from the class collection, and the children began discussing what kind of shelter their creature would need for protection from predators and the elements. As they chose materials, the children thought about what it might mean for that animal to feel safe. Creating shelters offered the children an opportunity to project their feelings and concerns onto their animal and imagine its needs. Most children have an affinity and empathy for animals, as long as the animal doesn't seem threatening. Understanding that expressing feelings is an important part of a child's

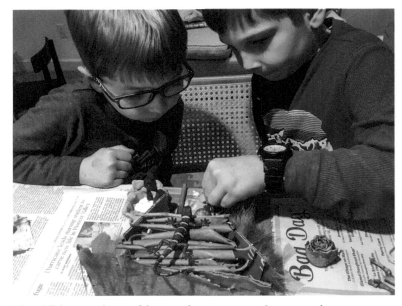

The children exchange ideas and spontaneously engage in dramatic play as they work.

All the gorgeous browns the children mixed inspires the teacher to create a brown color wheel.

sense of well-being, Rita asked, "What is a safe place?" The children shared their ideas:

My room. I can hide under my bed, and I have a fairy place where no one can come in except fairies.

A school. There's nice teachers.

Your home, because your parents are there to watch over you.

A museum, because it has a lot of fun stuff, so you don't have to worry about bad stuff. It's like a safe toy.

We noticed that many children selected the materials they had personally collected. Before building the shelters, the children needed time to experiment with the materials. They shared strategies, problem-solved, and thought about ways to attach the materials. To help with initial construction, Rita offered small pieces of corrugated cardboard. A slab of clay on a cardboard base helped anchor materials and became the ground for some of the shelters.

Parents became very involved in this construction experience, contributing materials, stories, and examples. One parent, who is an artist, did a beautiful oil painting of her daughter's shelter. That inspired many children to draw and paint their own shelters.

Collecting the brown natural materials abundant in our environment has opened up many new and powerful explorations, projects, and ways of working. Our study of colors helps us appreciate the gorgeous brown in ourselves and each other. ❧

Working with fragile materials requires concentration and skill. Zachary's roof features the rolled rhododendron leaves that he collected.

Ever-Changing Big Skies

ALBUQUERQUE PUBLIC SCHOOLS
ALBUQUERQUE, NEW MEXICO

Mary Bliss, Pre-K Teacher
Dona Sosa, Pre-K Teacher
Gigi Yu, Early Childhood Art Resource Teacher

The landscape in New Mexico is stunning. The high desert environment has sweeping views of valleys and ever-changing big skies. The skies are unencumbered by tall buildings that shut out light. Instead, the views and open skies give a sense of freedom to the psyche that attracts artists who seek to capture their feeling and beauty. We often share images of Georgia O'Keeffe's paintings with the children, as well as her quote, "I found I could say things with color and shapes that I couldn't say any other way—things I had no words for." Our four- and five-year-olds readily grasp this concept of seeing and interpreting the world through the language of colors and shapes.

"Today is cloudy and sunny. The clouds are going away."

Conversations Not to Be Missed

The world outside our New Mexico classrooms is filled with opportunities to observe transformation. We can't capture and hold onto the changing seasons or the fleeting cloud formations in the sky. However, these temporal experiences provide inspiration for the teachers and the children. Being outside gives us opportunities to listen and pose questions or share feelings, memories, and associations. These conversations are full of wonder and curiosity.

I see a mountain made of clouds.

I can see my grandma in heaven.

Some of the clouds look like animals.

Some of the clouds are bright and dark.

The sun is very hot. The sun is shining on us and makes the shadow.

We asked ourselves: How do we invite these feelings from the outside world inside? How do we give permanence to something impermanent? How do we capture the sky, clouds, and snowflakes?

Sky and Clouds

The majestic skies in New Mexico provide a palette for children to explore. Sometimes the sky is clear blue. Sometimes it is filled with soft clouds. It can quickly change to deep blues and grays and fill with powerful rain clouds. Spring in New Mexico is a magnificent time for studying the fleeting changes of the sky. One day the children noticed the bright blue sky and puffy clouds. We took photos and brought them inside to study. We offered them oil pastels and watercolor paints to recreate the clouds and sky.

The next day, while the preschoolers were playing outside, the weather changed. They noticed that the sky and clouds looked different.

I see clouds—dark and black.

I see these crazy clouds in the sky.

When the clouds are dark they are telling us they are about to rain.

I noticed the patterns in the sky—white, gray, and blue.

The children's observations outdoors were given form when they brought their predictions and theories about the changing sky indoors. They translated their ideas into paintings and drawings.

"All of the clouds look dark." "The clouds are darker over the mountains." "When the clouds are dark, your shadow goes away."

"I used blue and black together to look dark because the clouds are dark outside."

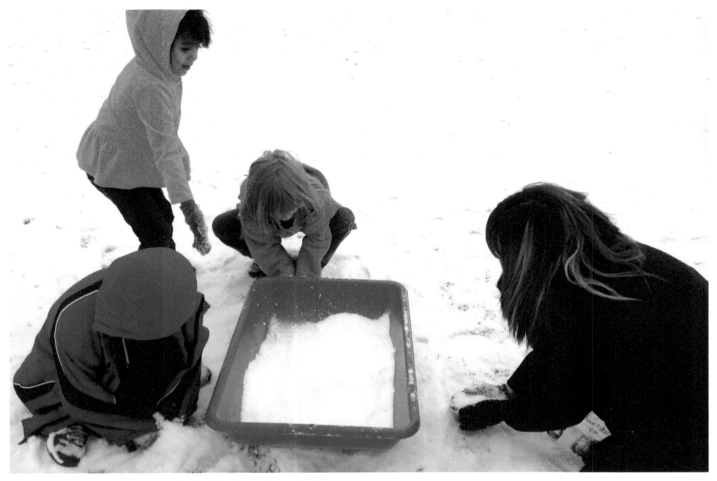

The children collect snow to bring inside for a closer look.

As teachers, it is a challenge to always be ready. We need to open our eyes, ears, and hearts to be prepared to notice and record the children's reactions to the ever-changing outdoor environment. The conversations, images, and the growth we have documented as the children delve into a phenomenon that interests them, has given us something to hold on to and study. This "being ready" is not easy. It means that we must find ways to focus our attention on the children's thoughts and follow their ideas. And children's thoughts and ideas change so quickly, just like the outdoor environment! But always having clipboards and cameras at hand has allowed us to see what children are capable of and where their interests truly lie.

"That's the shape inside the treasure." –Dominic

Finally, Snow!

Children in New Mexico wait with great anticipation for snow. Sometimes snow will come and sometimes it decides not to. One very exciting day, it snowed! The preschoolers ran, danced, and played in the snow. One of the children tried to capture a snowflake to look at up close. She became frustrated when the flakes melted in her hand. We asked ourselves how we could capture snow-flakes to see them up close.

We found magnified images of snow-flakes on the Internet and in books. The children began by studying the lines and patterns of the flakes. Then they created their own drawings. The quotes show that as they reflect on their draw-ings, they are "reading" their marks. This is a way that prereaders communi-cate ideas.

"I'm going to draw the little pieces … the hands. It needs to look like a snowflake. I'm drawing in the middle. I'm almost doing it. Look at all the tiny pieces in there."

"These are clouds. There is an up arrow. The up arrow means that is how the water sticks together. The down arrow means the snow is almost ready to go down …. These are two different snowflakes. Little clouds make little snowflakes and big clouds make big snowflakes."

Constructing Snowflakes
on the Overhead Projector

One of the children said, "The snowflakes look like sculptures." That gave us the idea to introduce wire, which added a new dimension. The perspective changed dramatically when wire formations were placed on the overhead projector. The children were fascinated with the transformation in size. They began playing with a variety of found materials on the overhead projector. It was a challenge to form snowflake designs, but as they worked, the radial structures started to truly become their own.

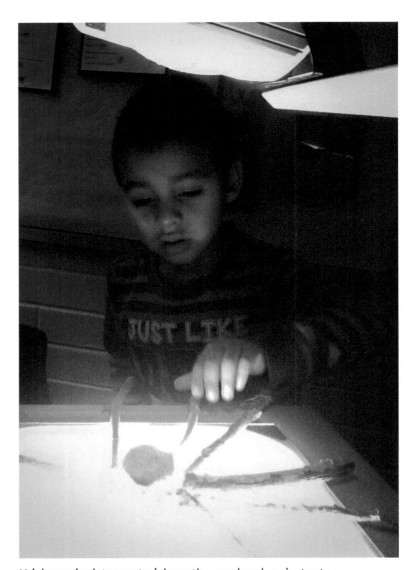

Uriah manipulates materials on the overhead projector to simulate the hexagonal structure of snowflakes.

"They're big up there [on the wall]. Here [on the projector] they're small." –Anaya

Recognizing the Extraordinary

We believe that inspiration drawn from nature integrates thinking, doing, and being. Preschoolers enjoy taking the intangible phenomena that they experience outdoors and giving them new life through their inquiry and imagination.

Conversations about the sky raised all of our awareness. Through this experience of observing the sky over time, we teachers have started to pay more attention to the natural wonders and richness of our New Mexico home. The children have picked up on our interest. They initiate more frequent and descriptive conversations about the sky and the weather, and share poetic thoughts and observations such as, "Look at the moon. I think of my mom when I look at the moon." or "Those clouds are moving fast. I think the moon is going to fall down with the wind." They look at the sky with a new awareness. We have learned to recognize the extraordinary in the ordinary moments of our daily lives with children. ∾

How can your snowflake exploration inspire a painting?

What would happen if we added color to the snowflakes? What colors could they be?

"I made the treasure first and then the hands. I used all the colors." –Rayon

Bringing Nature Inside

This is what I saw

Name of scientist :
eL jQ z

I looked at :
MY BULB

I noticed :

QT H A A
LOG STM
THAT LEEN
OVr

"It has a long stem that leans over." –Elias
Worksheets like this one combine science and literacy skills. Children notice and capture details through both words and observational drawing.

SPARKING DISCUSSIONS Being outdoors provokes important conversations about natural phenomena. Outside during free play, ideas and theories are easily exchanged. Explaining their theories, children often use surprisingly descriptive words. Teachers also cite the importance of having children share and discuss what they have noticed and make predictions before starting to work. It is through discussion that children in a classroom cultivate the ability to listen to one another, learn to see different perspectives as valuable, and exchange ideas in respectful ways. Teachers often feel they have to teach everything, but in fact, searching for answers with the children is an enjoyable part of the process.

DIALOGUE WITH MATERIALS When trying to construct a shelter, draw a snowflake, or mix a color, the children receive feedback from the materials and from their creative explorations. As a result, they are constantly readjusting their approaches. This dialogue with materials, tools, and art processes is hugely valuable but not often recognized as an important way of learning.

OBSERVATIONAL DRAWING Scientific drawing is a lifelong skill that children can develop in preschool. It is a precursor and segue to reading and writing. Drawing realistically from observation builds confidence. It takes concentration and is also satisfying. When using a black fine line marker with the cap still on to plan and practice a drawing, children can make mistakes and correct them without ever having made a mark. It gives them time to figure out where on the picture plane to make their first mark, and how big to make it. This technique slows them down and helps them focus. It only takes a few seconds, but it saves a lot of time, paper, and frustration. To make the addition of color exciting and special, keep crayons and colored pencils out of sight until line drawings are complete.

SHARING DOCUMENTATION Each story in this book is a thoughtful documentation of an experience. Each illuminates ways to observe and record children's fleeting moments of discovery and creation. We know you, the reader, must have stories about nature and children to share. Sharing is a way to continue to support the idea of exploration and discovery, not only in children, but also for adults.

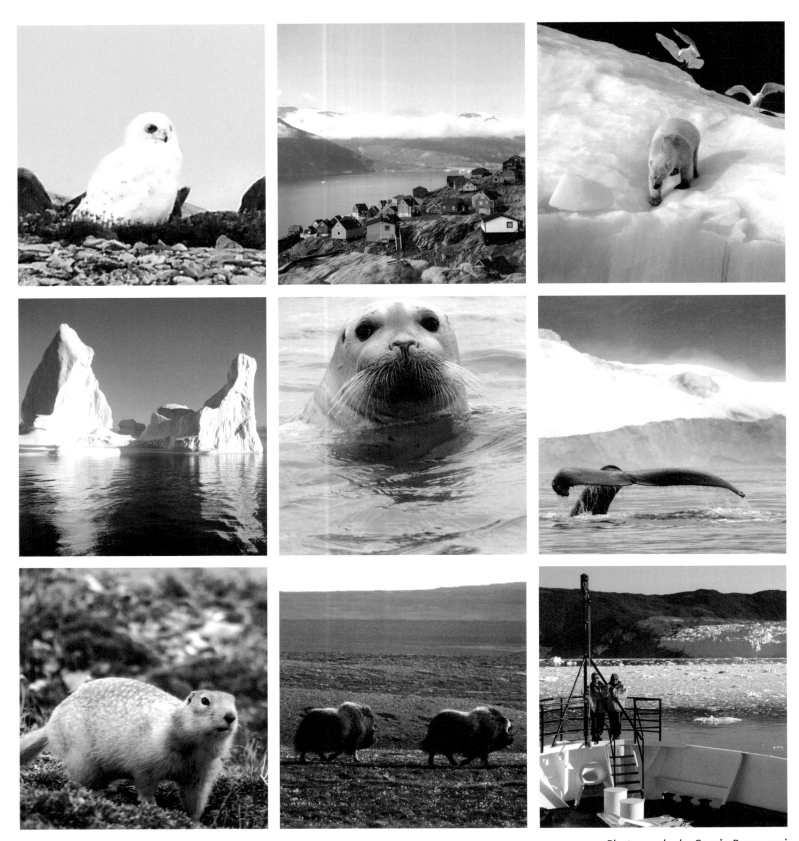

Photography by Sergio Bagnacani

A Report from the Arctic Circle

Last summer, while I was in the Arctic as part of a Northwest Passage expedition, I was at the top of the world. It was an incredible sensation. I was breathing the pleasure of being immersed in the power, the marvel, and the aesthetics of nature because I was surrounded by it.

The Arctic and Antarctica are places where much research is conducted in order to track global climate change year by year. Now that I am here, I can see it with my own eyes. It is moving, touching, and devastating. My husband, Sergio, and I visited Greenland six years ago, and now we can clearly see that some glaciers have lost a remarkable amount of ice. In general, navigating the Arctic, there are far fewer seals, birds, whales, and walruses. Polar bears are few. They look skinny and desperate when they walk the tundra in search of bird eggs or anything they can eat.

In the Canadian Arctic Circle in recent years, the ice has started to disappear in early spring, and in the summer the climate has become quite mild. Traveling in the Arctic, I was keenly aware of how much human behavior has dramatically and negatively influenced the precious natural balance of our world. The growing awareness of our impact on climate change has influenced how we look at nature. It is a delicate treasure that deserves attention, intervention, and protection. We must disseminate this critical message at all levels of society. Respect for nature must be at the foundation of our learning about the world around us.

As educators, we have a unique opportunity to influence the future of humankind. We can become researchers with children and parents to create a deep awareness about preserving our environment. We can facilitate children's natural curiosity about nature. We can help them translate that curiosity into a study that will generate questions about the fragility and changeability of nature. If we succeed, this study will be lifelong.

What we see now, what we admire now, must be defended and protected with love, sensitivity, and a deep sense of responsibility. Nature is beautiful, but that beauty cannot be taken for granted. To do so would be a huge and dangerous mistake.

We must tackle this global issue together. I share my experience in the Arctic with the intention of creating a deeper sense of belonging to our planet. However, you do not have to travel to the Arctic to teach an appreciation of nature. Each of us has a unique perspective to contribute about our own place on this Earth. Use the tools and the environment around you to inspire your teaching and engage your students in a study of their own place in this world. Our collective effort has the potential to improve the well-being of our beautiful nature, as well as bring hope to all humans. As I like to say, "Together is always better."

Amelia Gambetti, educator
Reggio Emilia Approach International Consultant
Reggio Emilia, Italy

Contributors

Jennifer Azzariti, Pedagogical Consultant, Myrtilla Miner Elementary School, NE Washington, DC

Nancy Baffa, Early Childhood Teacher, Touchstone Community School, Grafton, Massachusetts

Sabrina Ball, Director, Pinnacle Presbyterian Preschool, Scottsdale, Arizona

Mary Ann Biermeier, Director of Professional Development, Pinnacle Presbyterian Preschool, Scottsdale, Arizona

Mary Bliss, Pre-K Teacher, Albuquerque Public Schools, Albuquerque, New Mexico

Penny Block, Kindergarten Teacher, Campus School of Smith College, Northampton, Massachusetts

Rosalba Bortolotti, Director, Acorn School, Toronto, Ontario, Canada

Giovonne Mary Calenda, Early Childhood Studio Teacher, Lincoln School, Providence, Rhode Island

Mauren Campbell, Third-Grade Teacher-Researcher, Sabot at Stony Point, Richmond, Virginia

Maggie Chow, Atelierista, mem7iman Child Development Centre, shíshálh Nation, Sechelt, British Columbia, Canada

Simonetta Cittadini, Founder and Director, L'Atelier School, South Miami, Florida

Courtney Daignault, (former) Lead Pre-Kindergarten Teacher, Myrtilla Miner Elementary School, NE Washington, DC

Kacey Davenport, Preschool Co-Division Head, Riverfield Country Day School, Tulsa, Oklahoma

Meredith Duke, Teacher of Two-Year-Olds, McGehee's Little Gate, New Orleans, Louisiana

Kerri Embrey, Grade One and Lead Teacher, The Bishop Strachan School, Toronto, Ontario, Canada

Heather Evelyn, Kindergarten Teacher, The Bishop Strachan School, Toronto, Ontario, Canada

Sara Ferguson, Preschool Teacher-Researcher, Sabot at Stony Point, Richmond, Virginia

Marie Frank, Third-Grade Teacher, Campus School of Smith College, Northampton, Massachusetts

Marty Gravett, Director of the Sabot Institute for Teaching and Learning, Sabot at Stony Point, Richmond, Virginia

Suzanne Grove, Studio Educator, Cyert Center for Early Education, Pittsburgh, Pennsylvania

Kathleen Grzybowski, Lead Teacher, The Bishop Strachan School, Toronto, Ontario, Canada

Rita Harris, Teacher of Four-Year-Olds, Center for Early Childhood Education, Smith College, Northampton, Massachusetts

Renee Hemel, Assistant Director, McGehee's Little Gate, New Orleans, Louisiana

Janice Henderson, Kindergarten Teacher, Campus School of Smith College, Northampton, Massachusetts

Bob Hepner, Studio Art Teacher, Campus School of Smith College, Northampton, Massachusetts

Lynn Hill, Art Teacher and Volunteer, Giles Early Education Project, Giles County, Virginia

Amanda Humphreys, Lead Teacher, The Bishop Strachan School, Toronto, Ontario, Canada

Lenora Joe, Director of Education, Early Childhood Educator, mem7iman Child Development Centre, shíshálh Nation, Sechelt, British Columbia, Canada

Jennifer Kesselring, Preschool Co-Division Head, Riverfield Country Day School, Tulsa, Oklahoma

Shauneen Kroll, Teacher of Three-Year-Olds, Center for Early Childhood Education, Smith College, Northampton, Massachusetts

Amy Meltzer, Kindergarten Teacher, Lander~Grinspoon Academy, Northampton, Massachusetts

Amy Miller, Studio Teacher, Beginnings Nursery School, New York City

Mary Moore, Assistant Director of the Younger Cluster, Cyert Center for Early Education, Pittsburgh, Pennsylvania

Barbara Moser, Studio Educator, Cyert Center for Early Education, Pittsburgh, Pennsylvania

Robbie Murphy, Second Grade Teacher, Campus School of Smith College, Northampton, Massachusetts

Mary Murray, Kindergarten Teacher, The Bishop Strachan School, Toronto, Ontario, Canada

Melanie Nan, Fourth Grade Teacher-Researcher, Sabot at Stony Point, Richmond, Virginia

Jennifer Norviel, Toddler Teacher, Riverfield Country Day School, Tulsa, Oklahoma

Mimi Odem, Curriculum Coordinator, McGehee's Little Gate, New Orleans, Louisiana

Anna Papageorgiou, Kindergarten Teacher, The Bishop Strachan School, Toronto, Ontario, Canada

Andrea Pierotti, Third-Grade Teacher-Researcher, Sabot at Stony Point, Richmond, Virginia

Joella Reed, Early Childhood Educator, Cyert Center for Early Education, Pittsburgh, Pennsylvania

Dona Sosa, Pre-K Teacher, Albuquerque Public Schools, Albuquerque, New Mexico

Linda Stanley, (former) Paraprofessional, Myrtilla Miner Elementary School, NE Washington, DC

Cathy Weisman Topal, Studio Art Teacher, Center for Early Childhood Education and Campus School, Smith College, Northampton, Massachusetts

Gigi Yu, Early Childhood Art Resource Teacher, Albuquerque Public Schools, Albuquerque, New Mexico